A CULTURE IN THE MAKING

A CULTURE IN THE MAKING

New York and San Francisco in the 1950s and '60s

HACKETT-FREEDMAN GALLERY

250 Sutter Street, 4th Floor, San Francisco, California 94108 415.362.7152 Fax 415.362.7182 www.hackettfreedman.com

Published on the occasion of the exhibition:

A Culture in the Making
New York and San Francisco in the 1950s and '60s

Art Basel|Miami Beach
December 7 – 10, 2006

Hackett-Freedman Gallery
January 11 – March 3, 2007

Front Cover: Wayne Thiebaud *Antique Coin Machine* (detail) 38¼ x 30" oil on canvas, 1957

Back Cover: Willem de Kooning *Woman in a Rowboat* 12 x 9" pencil on paper, c.1960s

Sources for artists' quotations:

Brown: Karen Tsujimoto and Jacquelynn Baas, *The Art of Joan Brown* (Berkeley and Los Angeles: University of California Press, 1998), p. 24.

Diebenkorn: Gerald Nordland, *Richard Diebenkorn*, rev. ed. (New York: Rizzoli, 2001) p. 260, no. 138.

Frankenthaler: John Elderfield, *Frankenthaler* (New York: Harry N. Abrams, 1989), p. 24.

Graham: From *Reading Abstract Expressionism: Context and Critique*, ed. Ellen G. Landau (New Haven: Yale University Press, 2005) p. 146.

Hofmann: http://www.hanshofmann.net/quotes.html

Still: Mary Fuller McChesney, *A Period of Exploration: San Francisco 1945–1950* (Oakland: The Oakland Museum, 1973) p. 37.

Motherwell: Robert Motherwell, *The New York School* (Beverly Hills: Frank Perls Gallery, 1951), n.p.

ISBN: 1-933399-11-2
Catalogue design: Shore Design, Brisbane, California
Photography: PHOCASSO/J.W. White, except where otherwise noted.
Coordination: Tracy Freedman, Susan McDonough
Essay © 2006, Jed Perl
Publication © 2006, Hackett-Freedman Gallery, Inc.

Printed and bound in Hong Kong

CONTENTS

JOHN GRAHAM *Persian* 24 x 16" oil on canvas, 1943

DIRECTOR'S FOREWORD

We are proud to present this historical survey exhibition at Art Basel | Miami Beach 2006, and thereafter, in an expanded format, at our San Francisco gallery in January 2007. From the start, we recognized it would be a daunting challenge to compare the art produced in New York with that made in San Francisco in the two decades following World War II, much less to assess each community's impact on American culture then and now. And yet, the stories and personalities behind the development of American postwar art are irresistibly intriguing: abstract expressionism, gestural abstraction, and new figurative painting seemingly evolved all at once, in parallel developments on both coasts, yet with notable differences.

How is a culture built—how do environment, climate, institutions, and people come together to create something different from what came before? How was postwar San Francisco different from New York? Which city was cooler, hipper, and more original? Which city changed American art and culture more profoundly? The postwar period ushers in the east-west contrast, or rivalry, as some prefer, in American culture—a contrast clearly evident today in popular culture, and one that was manifested subtly, but clearly, in the visual arts in the 1950s and '60s. Inevitably, the discussion includes mention of San Francisco's established, anti-authoritarian culture dating to the time of the Gold Rush, the impact of its temperate climate on its citizens, and the presence, or lack thereof, of established art museums, galleries, and cultural institutions—all in contrast to New York with its established cultural milieu. This contrast between west and east came fully to light in the supercharged atmosphere after the war, when a national culture in suspension was suddenly awakened by a huge wave of returning veterans/artists tired of regimentation and false pieties and eager to study and make art, consort in universities and downtown lofts, and learn from older artists schooled in European modernism. Some of these returning GIs sought to join the existing art business; others, to avoid it; and still others, far from the center, opted to invent their own galleries and cultural resources.

Why look to the art of the 1950s and '60s? Why does this period seem so relevant to us fifty years later? Perhaps because the current social and political environment echoes that of those years, and today's artists and makers of culture face similar challenges, albeit in a far more developed, media-based consumer culture. As Irving Sandler notes in his 1978 history *The New York School*:

> "Artists were contemptuous of what they believed American society and its dominant culture had become after World War II (and very much as a result of the war), that is, a mixed welfare and garrison state in which a huge new middle class was achieving the American dream of affluence and, in the process, was embracing conservative, corporate, and suburban values with so little critical questioning that the nation seemed to be in the throes of a massive social conformity."[1]

More importantly, we look to the fifties and sixties because we remain powerfully moved and inspired by the art from this period, by its energy, invention, and intensity. Rather than argue that there is a uniquely American art form, much less a distinct variant coming from New York or San Francisco, we instead hope to explore and celebrate the breadth of styles that flourished and left a lasting imprint on American culture.

This show is not able to introduce viewers to a kaleidoscopic picture of the era and its creative energies. It is simply too big a task. We are limited to one example per artist, and many iconic names are not included for lack of available work to exhibit, or space in which to show it. Many of the individual stories and struggles, art communities and their subgroups will be obscured in this arrangement. There are also many 'what-ifs' we must leave unanswered—what if this artist had moved to New York? What if this one had stayed in San Francisco? What if art reproductions then were as accurate as today? One anecdote, from San Francisco artist Manuel Neri shows the vagaries of ascribing cause and effect to any one factor in an artist's career. When asked whether he, or other San Francisco artists, were influenced by reproductions of work from New York, Neri's answer, in a 1975 interview with San Francisco art critic Thomas Albright tells it all:

> "We'd look at those little black and white reproductions of de Kooning in the magazines, and we'd think that he was using really wild, crazy colors and sloshing them in big, thick layers. So we started painting right out of the can and building up surfaces a half-inch thick. Finally, some original de Koonings were exhibited at one of the museums. Most of us were really disappointed—the paint was so thin and the color was really dead. But the misinterpretation was a good thing." [2]

Clearly, there is no single truth or answer to the questions raised in this catalogue. Instead, we aim to show some notable works that moved postwar American visual culture and to reconstruct a bit of the intense interchange and excitement in American art at that time.

◆ ◆ ◆

Nowadays it is nearly impossible to view a de Kooning or a Kline in the intellectual context in which it was created—much less to see it as radical or shocking. These works are icons of a golden age, blue chip art commodities that we admire and see through a familiar lens. In this catalogue and exhibition, we try to expand the characters in the story beyond the famous and predictable, by including works from talented artists who are far less known today. In this, we were inspired by the work of our essayist Jed Perl, whose acclaimed *New Art City* provides one of the best and most comprehensive portraits of the many artists and ideas animating the postwar New York art world. Perl's account provides a far richer, more varied and complicated picture than the standard histories would suggest. Likewise, the story of San Francisco abstract expressionism and new figurative painting is often misunderstood and limited to a few recognized names, omitting many whose art still speaks strongly today.

Works by the well-known and the mostly forgotten, by artists based in New York and San Francisco, and by painters who trained in Europe and who studied on the GI Bill will hang side by side as they

MARSDEN HARTLEY *Red Flowers and Purple Vase* 28 x 22" oil on masonite panel, c.1941– 43

rarely did at the time they were created. We also include a small selection of prewar works by artists who deeply influenced this postwar generation: Marsden Hartley, John Graham, Josef Albers, Hans Hofmann, and Milton Avery. As the artworks interact with one another, we perceive new insights and connections and are surprised and moved anew. Viewing art, discussing it, and engaging with its sources, history, self-definition, and revolutionary implications is an act of social engagement and community. Then, more than now, artists and critics publicly discussed ethics, politics, aesthetics, and the role of the artist. Many artists sought to make art of transformative power that would improve the world. Whether that notion strikes you as noble or naïve, we want to move you to look again at artists and works both familiar and strange, to experience first-hand the excitement of a period of profound cultural change. As Sandler noted, the audience was a key participant in the ferment of the period:

"This audience *by paying attention* (enthusiastically) bolstered the artists and contributed to the intensity with which they worked. The energies that gave rise to, and were generated by, semi-public dialogue and the sense of vital community it implied were so elating to the participants that most recognized that they were witness to a rare phenomenon: a living culture and American at that."[3]

Richard Diebenkorn often said that being 'moved' by a work of art means more than being impressed or temporarily affected by something; *it means that one is somehow changed in attitude or point of view, so that ever afterward one exists in a different condition than they were before.*[4] We trust that you, too, will refresh your appreciation of the most famous generation and experience this culture in the making.

NOTES

1. Irving Sandler, *The New York School: The Painters and Sculptors of the Fifties* (New York: Harper & Row, 1978), p. 19.
2. Manuel Neri as quoted in Thomas Albright's "Manuel Neri: A Kind of Time Warp," *Currânt 1*, no. 1 (April–May 1975), p.14.
3. *The New York School*, p. 30.
4. Gerald Nordland, *Richard Diebenkorn*, rev. ed. (New York: Rizzoli, 2001), p. 260. (Italics added).

MILTON AVERY *Still Life with Mandolin* 24 x 30" oil on canvas, 1948

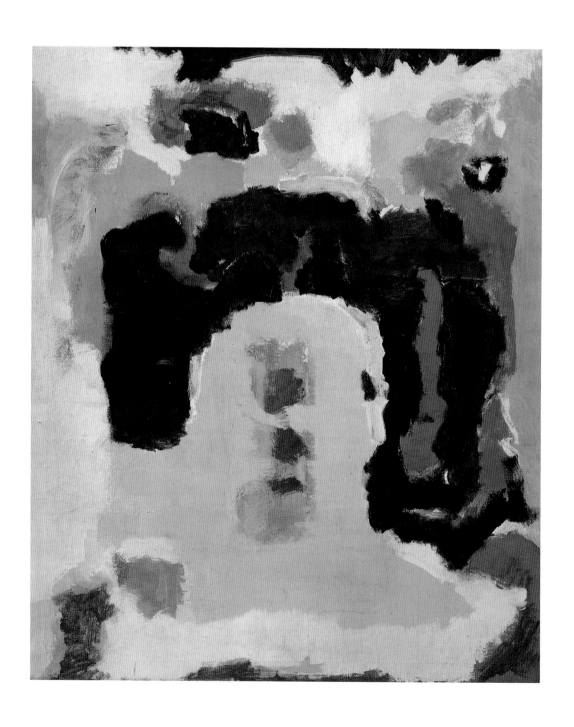

J E D P E R L

A TALE OF TWO CITIES

"The city is unspeakably beautiful & the weather perfect." These were Mark Rothko's words in a letter written from San Francisco in 1947 to a friend back East, the sculptor Herbert Ferber. Rothko had come to teach at the California School of Fine Art,[1] and he was enchanted by the summer in San Francisco, where the weather struck him as "benignly autumnal, combining a slight briskness with melancholy— nourishing my Slavic predilections." He sounded almost giddy about this new urban experience; he'd just returned from a spectacular sightseeing cruise around the bay. "There is no doubt," Rothko announced, "that by its visual attributes alone this city has earned the right to be the art center of the world, and that we must do something to bring this about. I suggest that we defame European art and expose Oriental art—thereby causing the commercial & ideological lanes to shift automatically to the Pacific."[2]

To read these lines by Rothko, an artist whom nobody would associate with any place but New York, is to grasp the appeal that San Francisco held for many adventuresome painters in mid-century America. Of course Rothko returned to New York—and it was New York that was becoming the art center of the world—but even back East he found himself recalling the exhilaration of the California School of Fine Arts, where Douglas MacAgy, the director since 1945, was encouraging a spirit of head-strong experimentation. It was MacAgy who had invited Rothko out for the summer to join a faculty that included Clyfford Still and Clay Spohn, the painter who would later dream up a Museum of Unknown and Little-Known Objects that introduced Dadaist enigmas to the students at CSFA. Like many of the great mid-century art schools—like the Hofmann School in New York and Black Mountain College in North Carolina—the California School of Fine Arts appealed to students who were less interested in a particular course of study than in a creative community. And there were plenty of young men and women who were hungry for the open-ended conversations that might bubble up in a classroom and spill over into afternoons and evenings in the galleries and bars of San Francisco and New York.

MARK ROTHKO
Untitled, 1947–48
48 1/8 x 40 1/8"
acrylic and oil on canvas,
1947–48
San Francisco Museum of
Modern Art

13

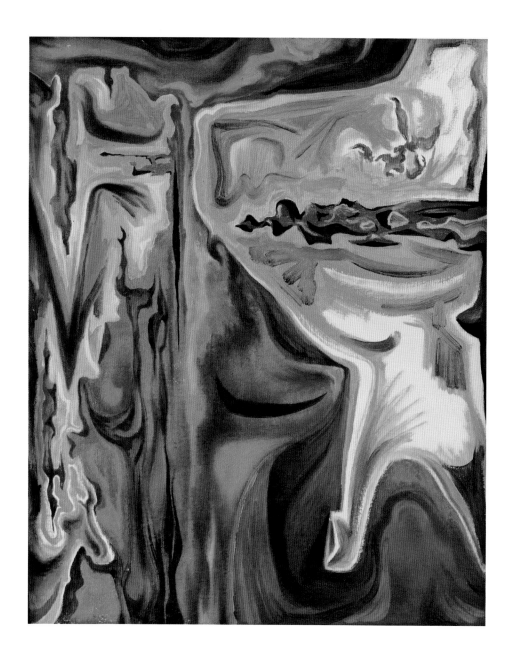

Rothko recalled the summer of 1947 in San Francisco as "magical." New York, by comparison, felt a little oppressive, like a place where there was nothing to do but work in solitude. "As I remember," Rothko wrote to Clay Spohn about CSFA, "there were a lot of pulls and twists which made me at that time wish it were over. Yet you, Clyff, Doug, etc. set up tensions which made us exist, I believe, on a very desirable plane, and I miss it. It seems that it [is] a good condition to live in."[3] That "good condition to live in"—a condition of artistic and intellectual tension, a tension that spurred creativity—was something that artists and writers were discovering all over the United States in the 1940s and 1950s. They were learning about the value of improvisation and surprise in small circulation magazines like *Dyn* and *The Tiger's Eye*, discovering Existentialist philosophy in the pages of *Partisan Review*, and devouring the erotic hyperbole of D. H. Lawrence's novels. They embraced the modern revolution in the arts as a transformation of human consciousness, and although many artists were immensely interested in developments that had taken place a generation earlier in London and Paris and Vienna

in the work of Pound and Picasso and Freud, they were mostly intent on demonstrating that the modern revolution was a permanent revolution. Rothko, arriving in San Francisco, was surrounded by artists who shared his concerns—who wanted to join what he had once described as "the small band of Myth Makers," those artists who were working in the United States during the war.[4] The impact of those Myth Makers, of the talismanic images of Still and Pollock and Rothko, could be felt in the work of painters who were studying at the School of Fine Arts—in the delicate, calligraphic signs that rise like spectral figures from Jack Jefferson's *Chestnut Street Untitled* series of the late 1940s, and in the somber resplendence, the purpled-black poetry, the labyrinth-enigmas of James Budd Dixon's canvases of the mid-1950s.

San Francisco, with its astonishing natural beauty and a history as free-spirited as that of any port city, was fertile ground for the modern adventure, not only in painting, but in the other arts as well. The singular struggle of the individual artist, in San Francisco and elsewhere, was fueled by an awareness of parallel activities, and painters were inspired, both directly and indirectly, by what writers and musicians and filmmakers were doing. In 1946–47, the San Francisco Museum of Art together with the city's Art in Cinema Society mounted a symposium and film series dealing with the experimental cinema—a large, rather audacious undertaking, ranging from early Surrealist works by Man Ray and Buñuel, to Cocteau's postwar movies, to *The Potted Psalm*, by San Francisco's own Sidney Peterson and James Broughton. An accompanying catalogue included writings by Henry Miller, Luis Buñuel, and Maya Deren, who had already directed and starred in the chiaroscuro enigma of *Meshes of the Afternoon*. Turning over the pages of the catalogue—which has a striking silkscreen cover, with undulating biomorphic patterns by Bezalel Schatz, one of the leading Surrealist painters in 1940s San Francisco—I can't help feeling that I'm reliving a red letter day in the history of the American avant-garde. And I suspect that the break-all-the-rules open-endedness of the art of the experimental film had a special significance for the creative spirits of San Francisco, who were touched by the same wonderfully unpredictable sea breezes that had blown in the lawless days when San Francisco was the Barbary Coast. Although Jess, whose later collages owe a good deal to experimental film, was not yet in San Francisco, the perfervid imagery of the avant-garde cinema surely left its

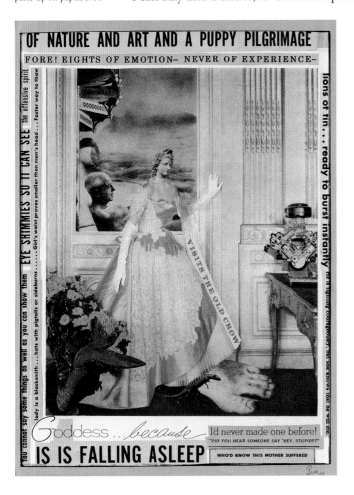

JESS
Goddess Because Is Is Falling Asleep
17 x 13"
paste-up on paper, 1954

mark on many abstract artists—and these were idiosyncratic marks, a pile-up of images as bizarre and as iconographically vexed as a sailor's torso full of tattoos.

Douglas MacAgy was among the co-sponsors of the "Art in Cinema" festival, and it's not hard to imagine that the artists who attended these sessions celebrating a new art form included some of the CSFA students as well as some members of the faculty, who were frequently nearly as young. In 1946 and 1947 that faculty included Elmer Bischoff, David Park, Edward Corbett, Clay Spohn, Hassel Smith, Richard Diebenkorn, and Clyfford Still; while among the students were Ernest Briggs, Lawrence Calcagno, James Budd Dixon, John Grillo, Frank Lobdell, and James Weeks. It was a formidable group of people—a significant part of what has come to be known as the San Francisco School.

Surely something was happening among these young San Francisco painters, teachers, and students, but how exactly we are to describe these developments, and in what ways they differed from what was happening in New York City, is not easy to say. These are not new questions. In the early 1950s, when a group of West Coast artists that included Sam Francis, Claire Falkenstein, and Frank Lobdell exhibited in Paris, the critic Michel Tapié dubbed them the *école du Pacifique.*[5] A few years later, the Oakland Art Museum sponsored an exhibition titled "California School—Yes or No?" And in 1973, when Mary Fuller McChesney wrote what remains the finest account of those years—*A Period of Exploration: San Francisco 1945–1950*—she said that among the discussions that she'd had with more than thirty artists who had worked in San Francisco, the majority seemed to believe that, yes, there was something distinctive about the painting that came out of San Francisco.

Time and again, the artists whom McChesney interviewed spoke about the ruggedness of San Francisco painting, what Ernest Briggs referred to as "a kind of wildness and delight."[6] Jorge Goya-

Studio 13 Jazz Band of the California School of Fine Arts, San Franciso, late 1950. (From left to right: Roland Howser, Jon Schueler, Jack Lowe, Elmer Bischoff, David Park, and Charles Clark).

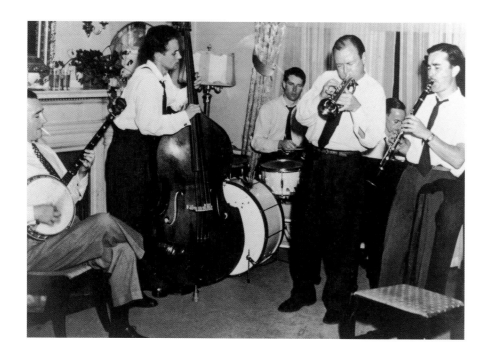

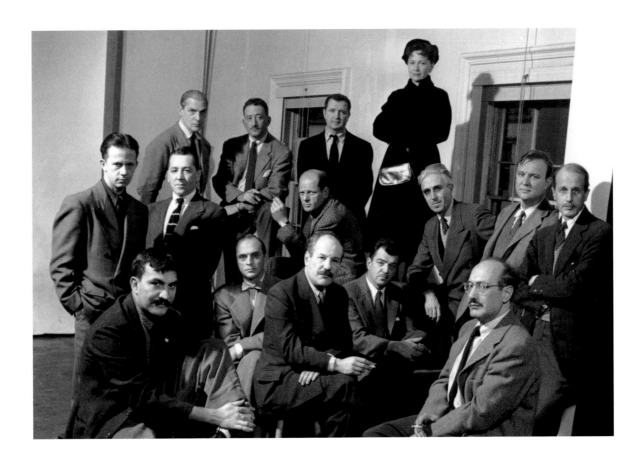

The Irascibles, 1950
(bottom, left to right)
Theodoros Stamos,
Jimmy Ernst,
Barnett Newman,
James Brooks,
Mark Rothko;
(second row)
Richard Pousette-Dart,
William Baziotes,
Jackson Pollock,
Clyfford Still,
Robert Motherwell,
Bradley Walker Tomlin;
(top row)
Willem de Kooning,
Adolph Gottlieb,
Ad Reinhardt,
Hedda Sterne.
Fourteen of the twenty-eight
artists who accused
The Metropolitan Museum
of Art of being hostile to
"advanced art," specifically
abstract expressionism.

Lukich argued that "the San Francisco painting had a more earthy organic quality about it than the New York school which was more intellectual in the kind of things it was making and talking about." And he then went on, comically, to explain that "the difference is like if you happened to run into a girl at the Cedar Bar and took her home or if you run into a girl in a hayfield and have a romp."[7] The artists who talked with McChesney generally believed that the New York painters remained more deeply involved with the School of Paris. John Hultberg commented that New York painting was "more artificial, symbolistic." The New Yorkers were "composing reality abstractly rather than painting nature non-objectively." Hultberg argued that the West Coast painters were responding to nature more directly than their friends in New York. "In California," he said, "I felt that what we were doing was organic, nature painting in a way. It represented part of nature."[8] And Robert McChesney spoke of California's "tremendous climate, tremendous landscape, open spaces," and how this inevitably had an effect on the artist, an effect very different than the New York environment, which he described as "that great mass of mess back there, turmoil, poverty, all sorts of action, muggings, buggings and everything else."[9] The San Francisco artists seemed to feel that in New York the man-made environment was so overwhelming and so alien that artists looked to painting as a realm apart—a realm that was shaped by historical precedents and abstract ideas. Whereas in San Francisco, where it was so much easier to live in sync with nature, the relationship between art and nature could be easier—"not nature copied but nature felt," as Hultberg put it.[10]

All of this talk could of course get pretty airy, but when the San Franciscans wanted to name an artist who epitomized this West Coast attitude to the art of painting, they almost invariably talked about Clyfford Still, whose tenure at the California School of Fine Arts between 1946 and 1950 left his stamp on many of the painters who studied there. Still was a slender, striking, rather severe presence—a man who brought a stand-alone authority to modern art. Although by the early 1950s his base of operations was in New York, he had come of age in the West, and his paintings, so full of strong colors and jagged forms, had a rough-hewn lyricism that was his alone. Those canvases, with their Gothic imagery and burning-embers tonalities, looked startlingly raw in the late 1940s. And the message that Still brought to his students had a related, inward-turning, yet feverish, drama. When artists who had come under Still's impact tried to explain what he had meant to him, it turned out to have less to do with anything specific that he said than with the cool ferocity of his personality, his insistence that you must draw something out of yourself, that students had "to work things out for themselves."[11] You were on your own, Still argued. "I don't believe in historicity," somebody paraphrased him as saying. "I don't believe in museums. I don't believe in memory. I don't believe in the

Renaissance."[12] And this attitude—with its skepticism about all precedents, its eagerness to start anew—lit a fire under many of the young artists who were studying at CSFA and, in the process, raised considerable controversy among the faculty.

Frank Lobdell's *3 September 1948* is a canvas that comes close to defining the spirit of artistic San Francisco in those mid-century years. There's something gruff and recalcitrant about this painting; the undulating, wavering, meandering forms don't fit easily within the tall, vertical format. Lobdell wants his visionary images—with their veiled echoes of Northern California's windswept trees, rocky outcroppings, and meandering coastline—to take on a life of their own. The composition spills beyond the edges of the canvas, urging us to imagine what we cannot see, as we sometimes do

when we study the curious framing of landscape elements on a Japanese scroll. Perhaps Lobdell found the very act of composing a painting—of discovering a pattern that could contain an imaginative world—somehow constricting. What we discover here is not so much a completely resolved painting as a glimpse into the artist's excitable, adventuresome imagination. And indeed it is some element of roughness, some sense that an artist is refusing to settle things once and for all, that characterizes much of the work that's associated with mid-century San Francisco.

To speak of a San Francisco style or of a New York style is of course to risk, indeed almost to embrace, oversimplification. And yet who cannot doubt that the Bay Area had its own kind of impact on the younger abstract artists of the 1940s and 1950s? Looking at photographs of West Coast painters such as John Hultberg and Jack Jefferson and Edward Corbett in their studios, I'm struck by a roll-up-your-sleeves-and-get-to-work sense of physical well being that I can't recall seeing among the New Yorkers. And in a snapshot of Corbett and Robert and Mary McChesney and a bunch of other people at a picnic in the Sonoma Mountains in the late 1940s, the bright light and deep shadows and open faces bring to mind photographs of bohemian gatherings in Southern France. The Californians were living in a world of wide-open vistas, and it may be that they saw some reflection of that limitless space in Clyfford Still's slabs of color, which suggested the details of a vast, as-yet-to-be-known realm.

It may also be possible that Rothko's visits to San Francisco in 1947 and 1949 precipitated the increasingly hedonistic quality of his color and the increasingly open character of his forms.

New York had its own visual drama, but it was a drama that had everything to do with the boxed-in spaces of the city. Even when Pollock chose to fling or drip paint, he insisted that his expansive arabesques be contained by the sides of the canvas. And in the black-and-white abstractions that de Kooning was working on in the late 1940s, the chaotic yet essentially rectilinear character of the city provoked a decisively contemporary response to the very compositional traditions—the traditions of Poussin and Cézanne and Cubism—that Still was determined to reject. Surely there is something to the

FRANK LOBDELL
3 September 1948
92 ¹/₂ x 41 ³/₄"
oil on canvas, 1948

EDWARD CORBETT
Mexico
13 ½ x 30 ½"
charcoal on paper, 1953

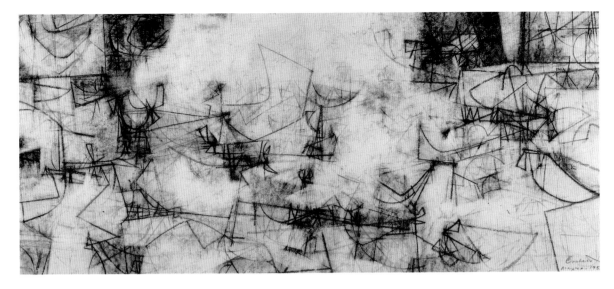

idea that the San Franciscans were more inclined to work against the inherently architectonic nature of the canvas. In a 1958 painting by John Saccaro, the excitable bursts of brushwork bump up against the edges of the canvas and even suggest a yearning to escape from the canvas entirely. By contrast, in a small, smoke-gray canvas painted by Joan Mitchell in 1953, the entire world is easily contained within the architecture of the rectangle.

When in the 1950s a number of artists associated with CSFA started painting figures and landscapes, some observers saw this rejection of abstract orthodoxies as animated by the renegade spirit of the West. The truth was that there were also a great many artists—including Fairfield Porter, Robert De Niro, Sr., Alex Katz, and Leland Bell—who were moving in parallel directions in New York. But a case can be made that the San Franciscans, especially David Park, Elmer Bischoff, and Richard Diebenkorn, were less interested than their New York counterparts in responding directly to the School of Paris, although Diebenkorn was of course very much a student of Matisse. Porter, who was writing criticism in the late 1950s and early 1960s, seems to have believed that the San Francisco painters were more willing than their East Coast counterparts to sacrifice the truth of objects to what he referred to, in writing about Bischoff, as paint's "powerful flow."[13] Porter commented of Diebenkorn's interiors

Elmer Bischoff, Frank Lobdell, and Richard Diebenkorn at Lobdell's 9 Mission Street studio, San Francisco, 1959.

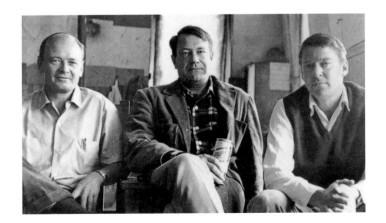

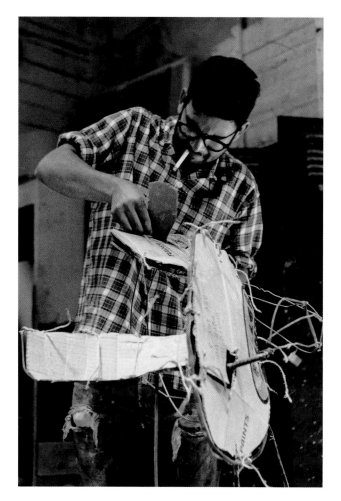

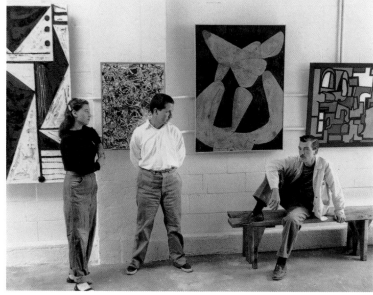

that "the definiteness of structure comes from the indefiniteness of spatial relations."[14] What Porter was describing in the work of Bischoff and Diebenkorn may have not been entirely different from what some saw in Still, although of course the San Francisco realists were by no means admirers of Still. To a New Yorker's eye, the School of San Francisco, whether abstract or representational, was characterized by a refusal to accept the constraints of objectivity, an insistence on investigating some personal ambiguity.

Around 1960, Porter filled a couple of pages in a date book with small sketches after some of Diebenkorn's representational paintings. I'm fascinated by these glimpses of the New York painter contemplating the work of the San Franciscan. I suspect that Porter, in exploring the Diebenkorn structures that he'd already described as based on a refusal to consider spatial realities, was perhaps challenging his own allegiance to those realities. Of course de Kooning, the New York painter who was most important to Porter, had already deconstructed the female form with a vehemence that made the work of many of the San Franciscans look positively normative, so we must be wary about exaggerating the objectivity of New York. But there is an immediacy to the figures in David Park's paintings, a sense of private confrontation that I don't associate with figure painting in New York. It's interesting to compare the work of Park and De Niro, two representational artists who were committed to the

JOAN BROWN
Noel and Bob
72 x 60¼"
oil on canvas, 1964
Fine Arts Museums of
San Francisco

expressionist brushstroke. While De Niro's brushwork suggests a longing for the grandeur of the Old Masters, Park's conveys a vigorous immediacy. And Diebenkorn's representational work, especially the ink drawings and etchings, with their melancholy evocations of the fog-bound Bay Area atmosphere, can cast a spell that's as full of dark-toned mystery as Clyfford Still's abstractions. Perhaps the essential difference between painting in New York and painting in San Francisco was that the New Yorkers always aimed for a high style while the San Franciscans were more interested in a personal style.

To explore the dynamic relationship between San Francisco and New York in the mid-century years is to be struck by a sense that there are indeed large distinctions to be made, although the precise nature of those distinctions remains difficult if not impossible to determine. But in all our efforts to grasp these differences, what we may sometimes be in danger of forgetting is that New York and

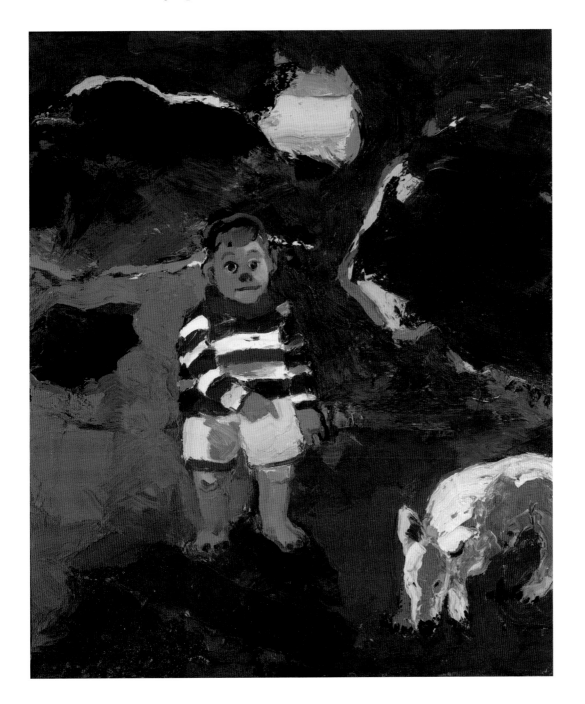

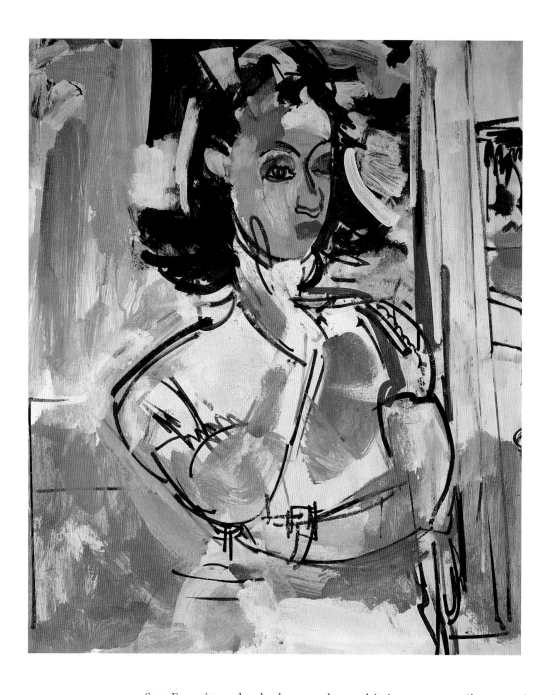

San Francisco also had more than a bit in common. I've mentioned the physical beauty of San Francisco. New York had its own astonishing beauty, and Manhattan's high, clear, dazzling light left its mark on the work of many artists, including Fairfield Porter, who painted a series of views of the city's streets in the 1970s. Both of these cities were great American ports, centers of mercantile activity throughout the nineteenth century. And if New York struck many as America's answer to London or Paris, San Francisco's charms could be compared with the smaller-scaled but still enormous allure of Barcelona or Marseilles or Aix-en-Provence; in the 1950s and 1960s many people argued that San Francisco was the only truly livable cosmopolitan center in the United States. The fact is that both New York and San Francisco were cities in which young American artists and writers were gathering to reaffirm the richly complex relationship between cosmopolitanism and modernity, a relationship that had been born in the European capitals in the late-nineteenth and early-twentieth centuries and

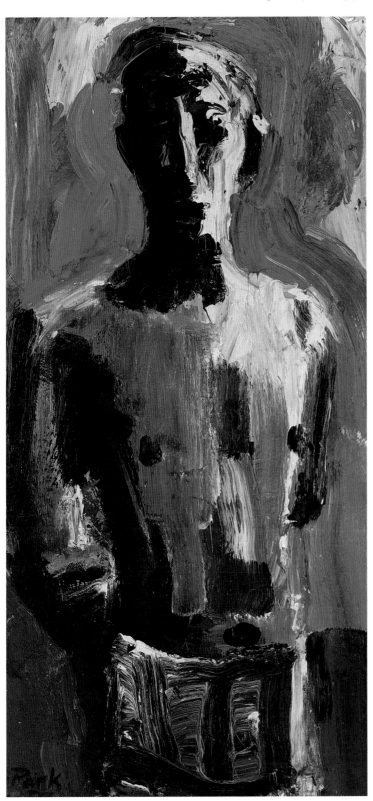

was now at last flourishing in the New World. In the 1950s, at a time when painters and writers were increasingly curious about Asian art and literature and philosophy, San Francisco could in some respects feel more cosmopolitan than New York, more immediately open to what the future held in store.

Perhaps the best way to understand New York and San Francisco is as two sides of a single equation. The creative spirits in these cities sometimes emboldened one another, and that sense of mutual enrichment comes through very strongly in the letters of the San Francisco poet Robert Duncan and the New York poet Denise Levertov. Duncan has interesting things to say about the painters, beginning with Still, whose work he says was indirectly responsible for his getting to know Jess, whom he met in 1950 and with whom he lived for the rest of his life. Still was for Duncan a man who "in his ardor or fury can achieve beauty—where the personal elements of the ikonoklasm are transmuted into a composed spiritual fact." That could double as a description of a number of San Francisco painters. It was seeing a show of Still's painting in San Francisco in 1950 that led Duncan "to stay in San Francisco instead of going to Europe, and to search out the new painters where I found Jess."[15] But it was not only the San Francisco painters with whom Duncan was friends. He was for a time close to De Niro and Virginia Admiral, who by the 1950s were figures in the Manhattan art scene. They had both studied with Hans Hofmann, who was instrumental in shaping the understanding of modern art in New York in the 1940s and 1950s, but who had first taught in the United States in Berkeley in the early 1930s.

Through Levertov, Duncan became aware of a number of New York painters, among them Leland Bell and Louisa Matthiasdottir, another Hofmann student. Writing to Levertov after a visit to New York, Duncan was disapproving about what he saw as the New Yorkers' "necessity to put down or put in its place work which to

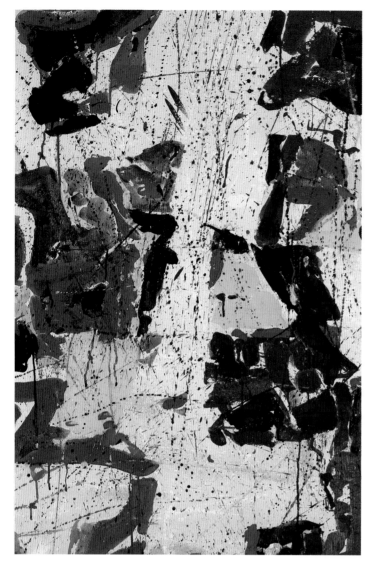

SAM FRANCIS
Untitled White Line
39 ¹/₄ x 26 ¹/₂"
oil on paper mounted on
masonite, 1959

our uncompeting eyes had had its own free wonders."[16] And in her very next letter to Duncan, Levertov seemed to only add fuel to Duncan's sense of the contentiousness of New York, when she related that her husband, Mitch, had just "had a violent argument in the Cedar bar with and about Franz Kline."[17] This was not to say that San Francisco did not have its fair share of arguments—surely Duncan could be tough in dispute—but there was perhaps an air of hard calculation about New York that San Francisco was glad to leave to others. What comes through most strongly in the back-and-forth of Duncan's and Levertov's letters is how much New Yorkers and San Franciscans had to say to one another—and the extent to which New York and San Francisco could look like different neighborhoods in one great city of modern art.

Thinking of Duncan's and Levertov's eagerness to know what was happening on the other coast—and Rothko's exhilaration during his time at the California School of Fine Arts—we can see that in the expansive postwar atmosphere a new sense of creative possibility was bursting open in a number of locales almost simultaneously. Among the points of this creative compass were Provincetown, Gloucester, East Hampton, Key West, Taos, Los Angeles, as well as cities and idyllic rural spots in Mexico, Spain, Italy, France, and Japan. Artists and writers wanted to know what was happening in these different places, and liked to move from one place to the other, and spend time away from home in a place that could come to feel like a second home. For many people, though, New York and San Francisco remained the magnetic poles of the arts in mid-twentieth-century America, two urban centers charged with strong energies, energies both complementary and contradictory. Looking back, we may feel that in New York there was a fierce desire for clarity, a desire that, while not

Hans Hofmann painting on the dunes in Provincetown, 1943.

necessarily denying the fascinations of ambiguity, was nevertheless fueled by a determination to match the formal lucidity of the School of Paris. In San Francisco, however, there was a willingness to embrace the risks of ambiguity, to paint so personally that the canvases might become, as Duncan said of Still, "acts in themselves," although this was an inwardness that did not always rule out a clarifying elegance.[18] If San Francisco, with its what-the-hell freedom, was nevertheless fascinated by New York's gravitas and boundless egotism, what New York saw and envied in San Francisco was an easygoingness, an unruliness—a celebration of the unexpected and inexplicable passions and possibilities of the id.

Jed Perl is an author and critic. Among his books are *Paris Without End: On French Art Since World War I*, *Eyewitness: Reports from an Art World in Crisis*, and *New Art City: Manhattan at Mid-Century*. He is currently the art critic for *The New Republic*.

NOTES

1. The California School of Fine Arts changed its name to the San Francisco Art Institute in 1961.
2. Mark Rothko, *Writings on Art*, ed. Miguel López-Remiro, (New Haven: Yale University Press, 2006), p. 53.
3. Ibid, p. 60.
4. Ibid, p. 48.
5. Susan Landauer, *The San Francisco School of Abstract Expressionism* (Berkeley and Los Angeles: University of California Press, 1996), p. 14.
6. Mary Fuller McChesney, *A Period of Exploration: San Francisco 1945–1950* (Oakland: Oakland Museum, 1973), p. 77.
7. Ibid, p. 75.
8. Ibid, p. 79.
9. Ibid, p. 78.
10. Ibid, p. 79.
11. Ibid, p. 43.
12. Ibid, p. 36.
13. Fairfield Porter, *Art in Its Own Terms: Selected Criticism 1935–1975*, ed. Rackstraw Downes, (New York: Taplinger Publishing Co., 1979), p. 92.
14. Ibid, p. 60.
15. Robert Duncan and Denise Levertov, *The Letters of Robert Duncan and Denise Levertov*, ed. Robert J. Bertholf and Albert Gelpi (Stanford: Stanford University Press, 2004), p. 239.
16. Ibid, p. 21.
17. Ibid, p. 23.
18. Ibid, p. 239.

J O S E F A L B E R S *Homage to the Square* 24 x 24" oil on masonite, 1952 – 56

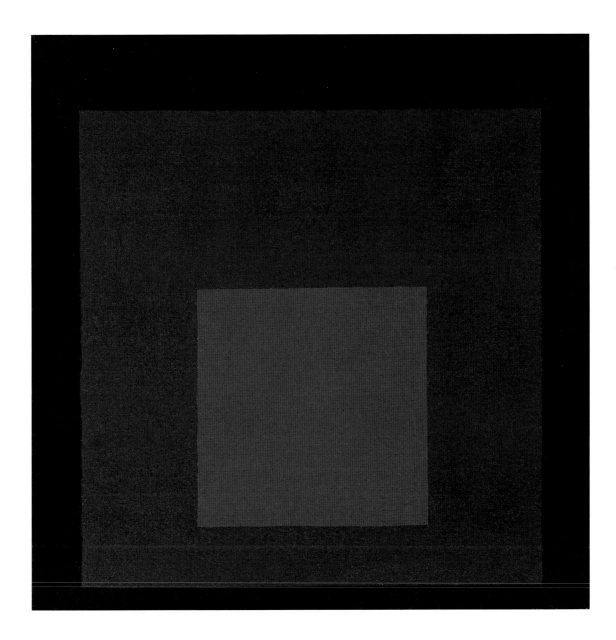

LOUISE NEVELSON *Untitled* 39¾ x 30" mixed-media collage, 1957

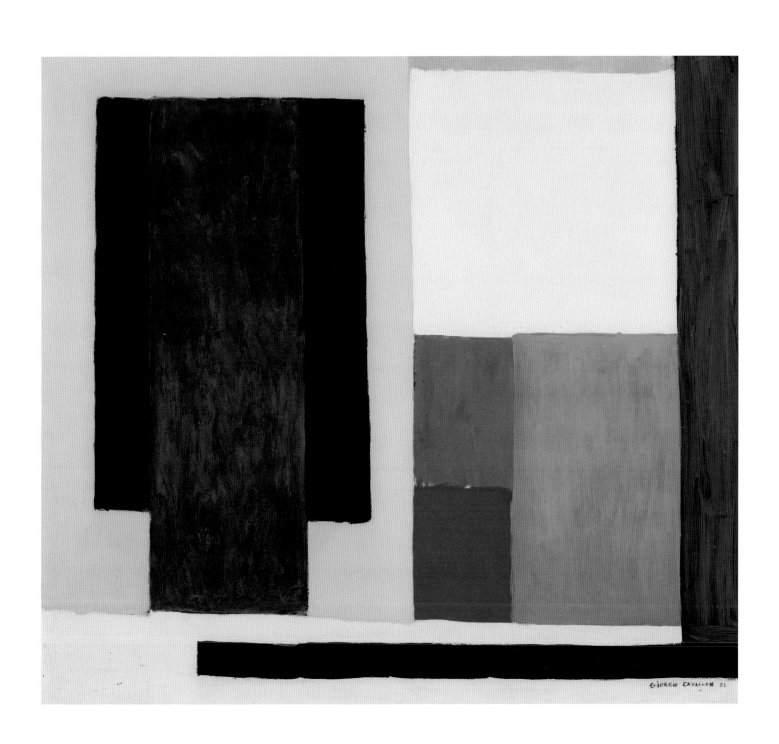

GIORGIO CAVALLON *Untitled* 36 x 40" oil on canvas, 1952

CHARMION VON WEIGAND *The Red Square* 14 1/4 x 14 1/4" gouache on board, 1964

MANUEL NERI *Window Series No. 18* 47 1/4 x 47 1/2" oil on canvas, 1958 – 59

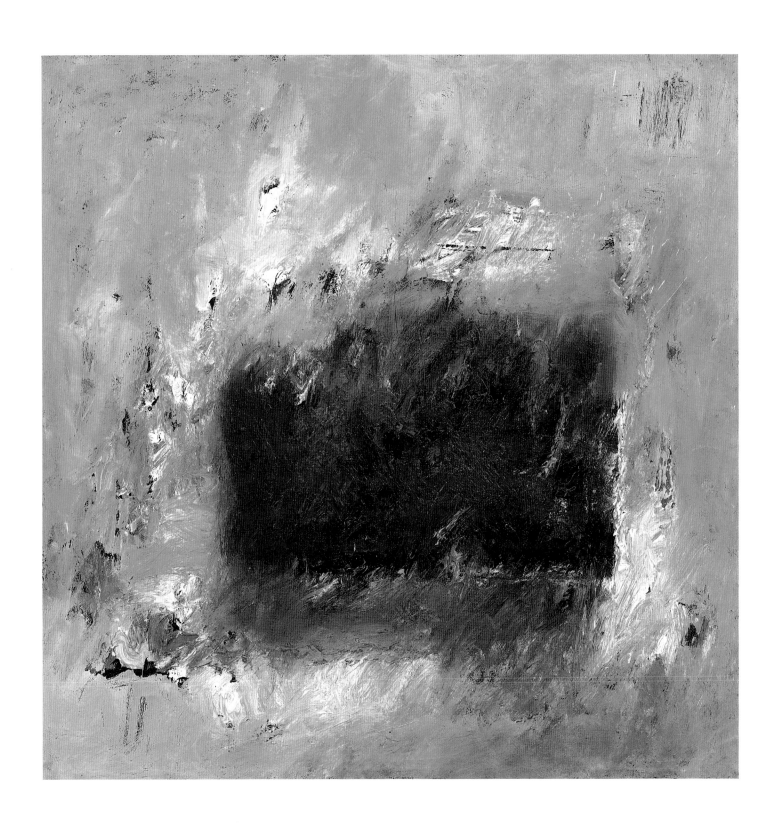

CONRAD MARCA-RELLI *M-S-1-59* 36 x 40" oil and canvas collage on canvas, 1959

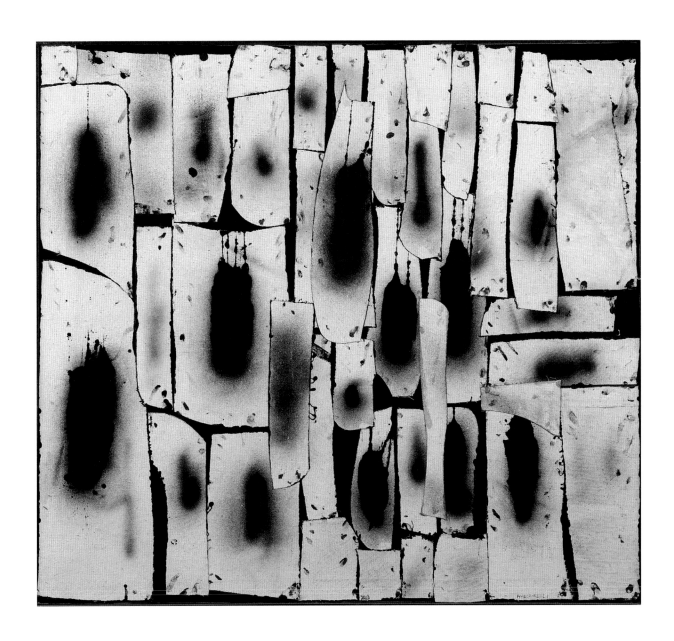

R I C H A R D S T A N K I E W I C Z *Family with Pet* 19 ¹/₄ x 15 x 9" welded iron and steel, 1957

HELEN FRANKENTHALER *Burnt Orange Roof* 12 x 16" oil on panel, 1961

42 J O H N H U L T B E R G *Kline Form* 24 ¼ x 30" oil on canvas, 1962

F R A N Z K L I N E *Untitled* 13 x 15³/₄" ink on paper, 1952

A L H E L D *Untitled* 22 $^{1}/_{2}$ x 28 $^{1}/_{2}$" acrylic on illustration board mounted on masonite, 1966

H A N S H O F M A N N *Nocturn* 60 x 52" oil on canvas, 1962

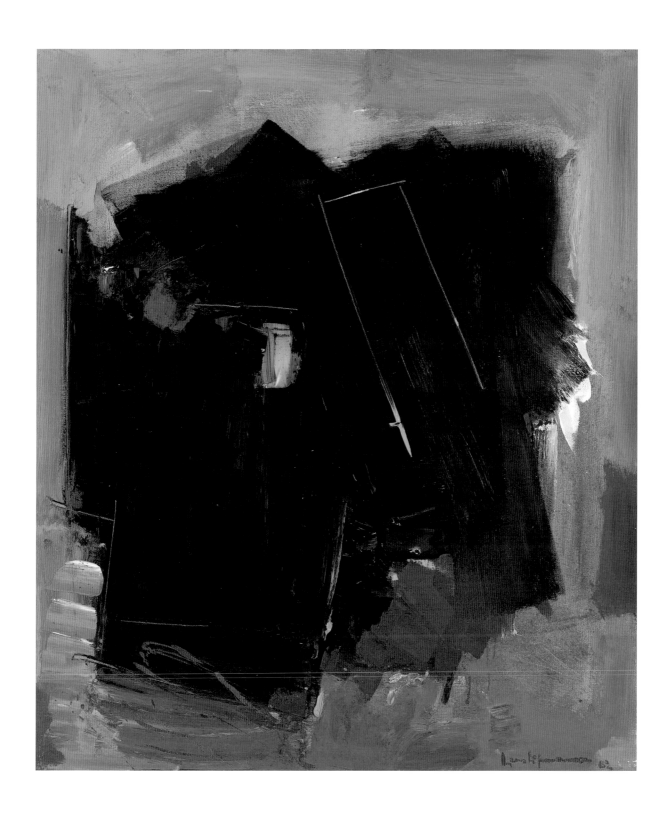

H E R B E R T F E R B E R *Spheroid* 40 x 25 $\frac{1}{2}$ x 26 $\frac{1}{2}$" copper, 1954–62

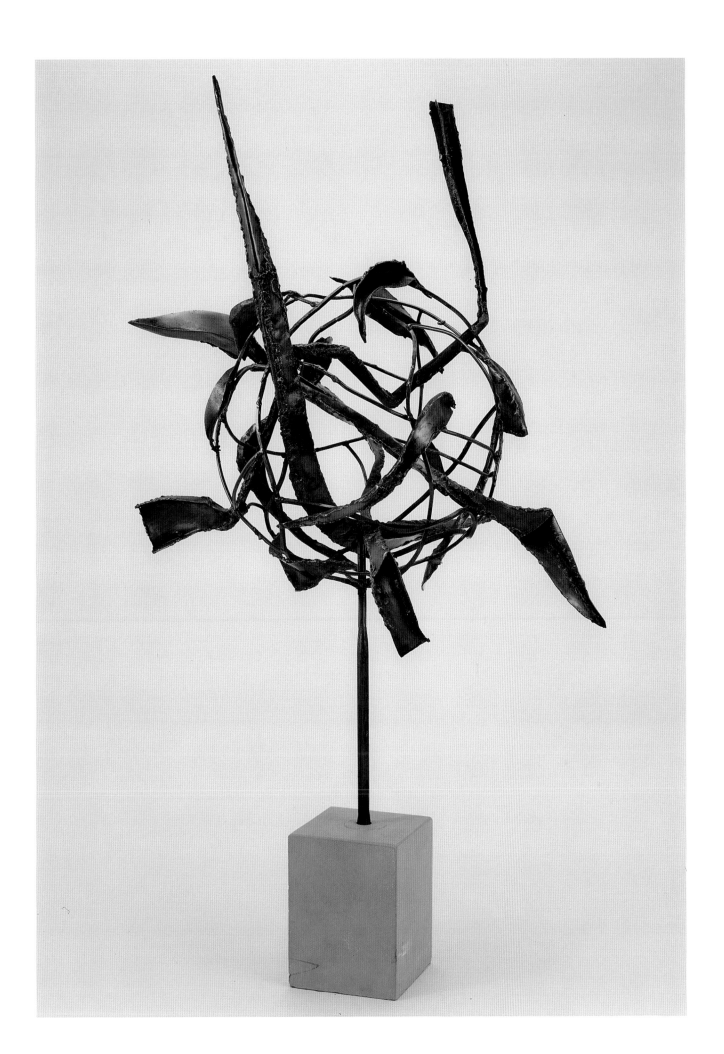

JUDITH ROTHSCHILD *Prisms and Pavannes* 25 x 34" oil on canvas, 1955

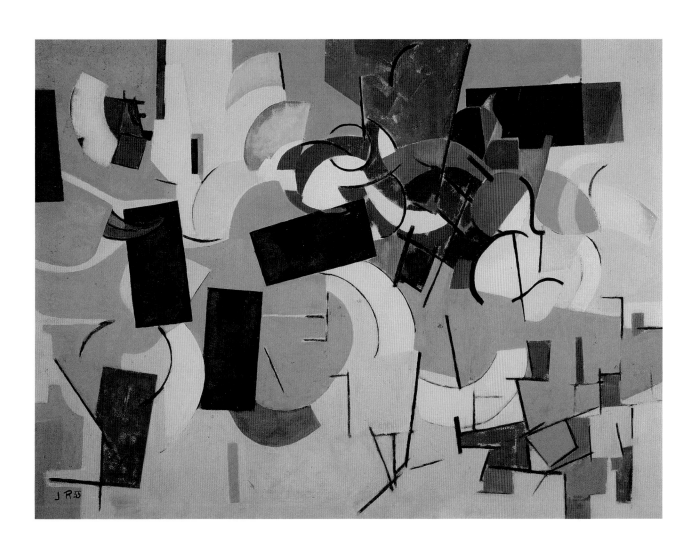

R I C H A R D D I E B E N K O R N *Untitled (Berkeley)* 16 3/4 x 13 3/4" ink on paper, 1954

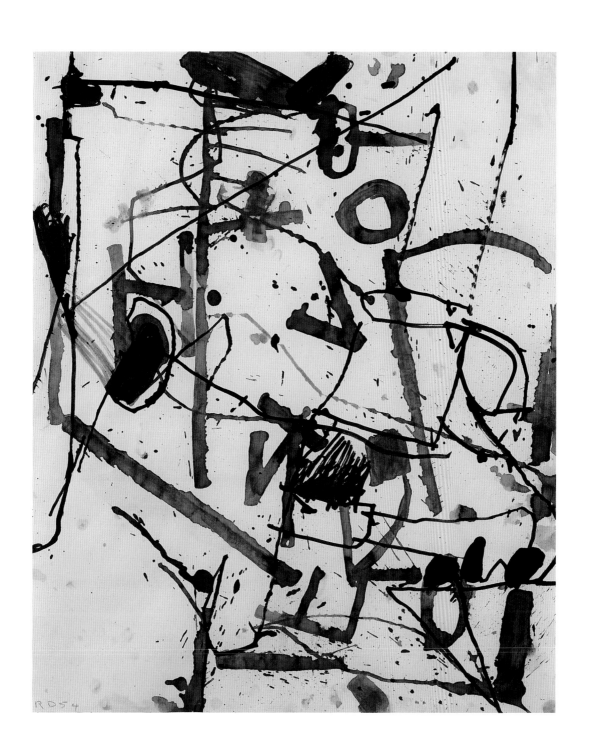

FRED MITCHELL *Narrows* 56 x 29 3/4" oil on canvas, 1958

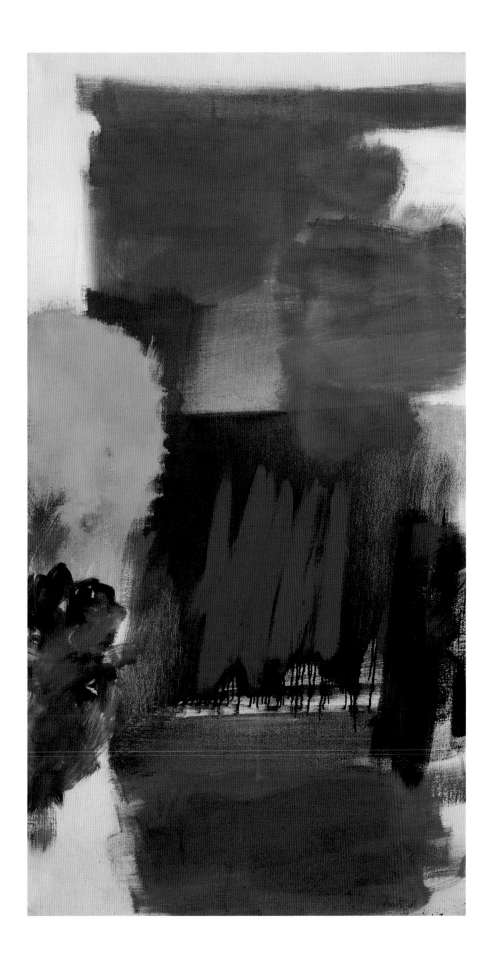

A D R E I N H A R D T *Untitled* 49 ¾ x 20" oil on canvas, 1943

JAMES BUDD DIXON *Untitled* 63 x 32 ¹/₄ oil on canvas, 1955

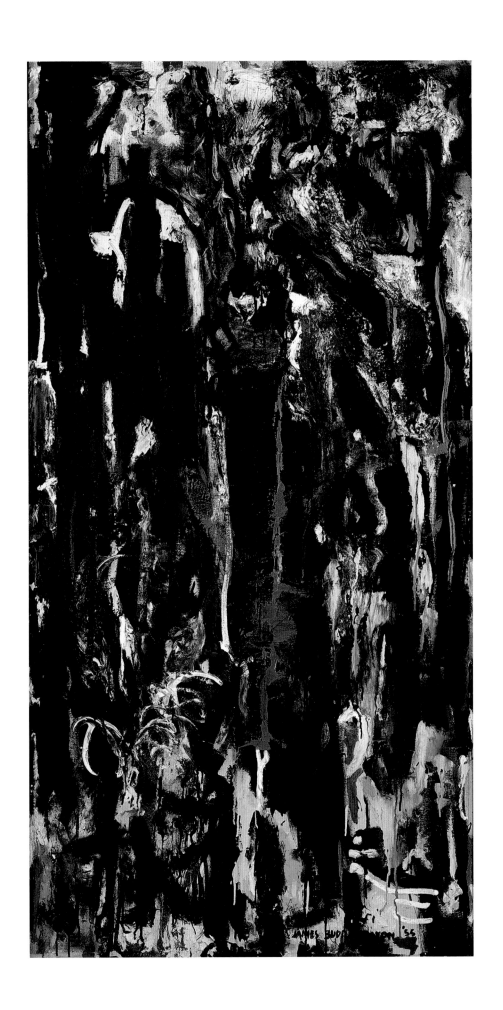

THEODOROS STAMOS *The Cleft* 48 x 22" oil on panel, 1949

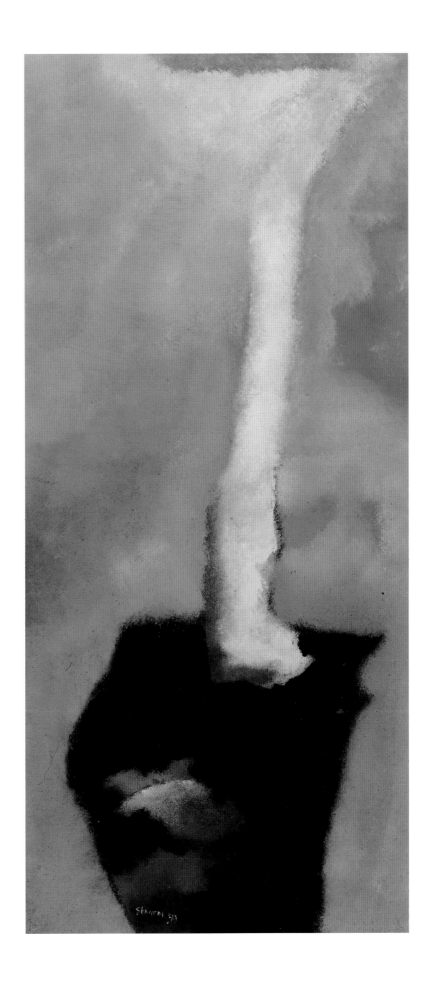

JACK JEFFERSON *Chestnut Street Untitled* 38 x 40" oil on canvas, 1948–49

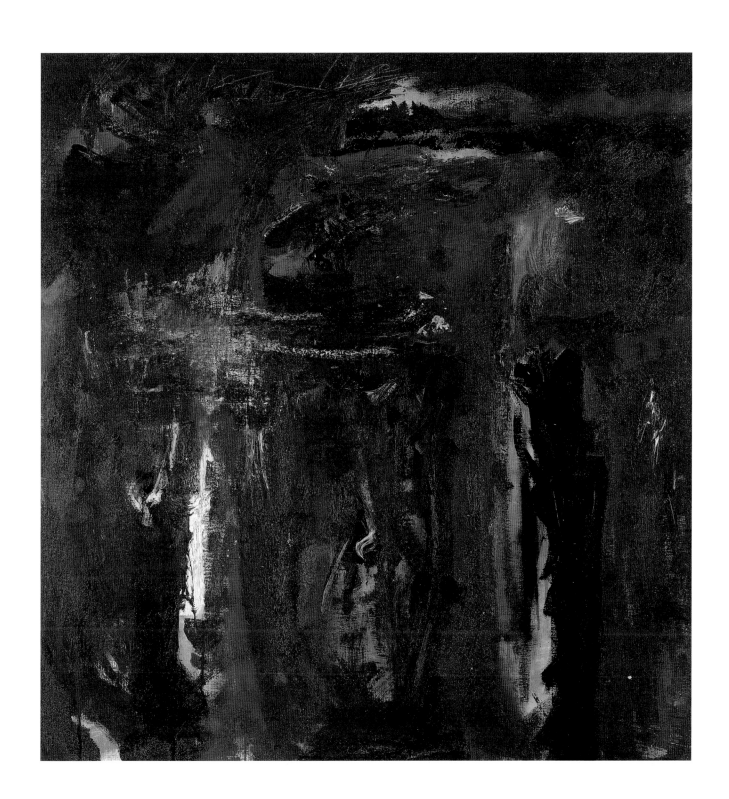

F R A N K L O B D E L L *July 1954* 66 ³/₄ x 49 ¹/₄" oil on canvas, 1954

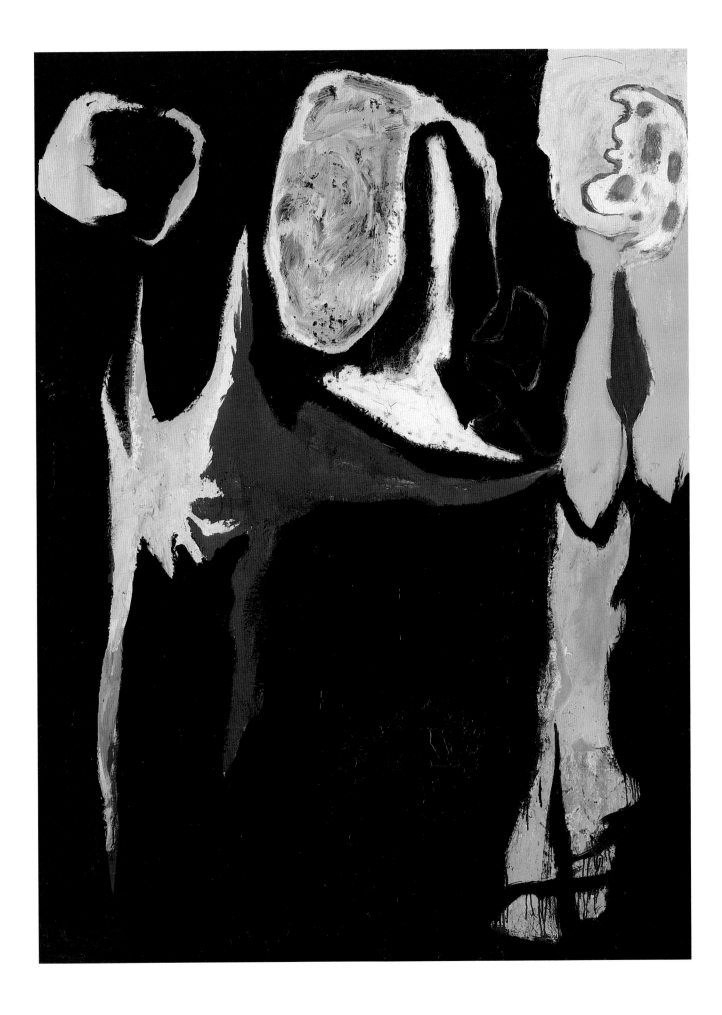

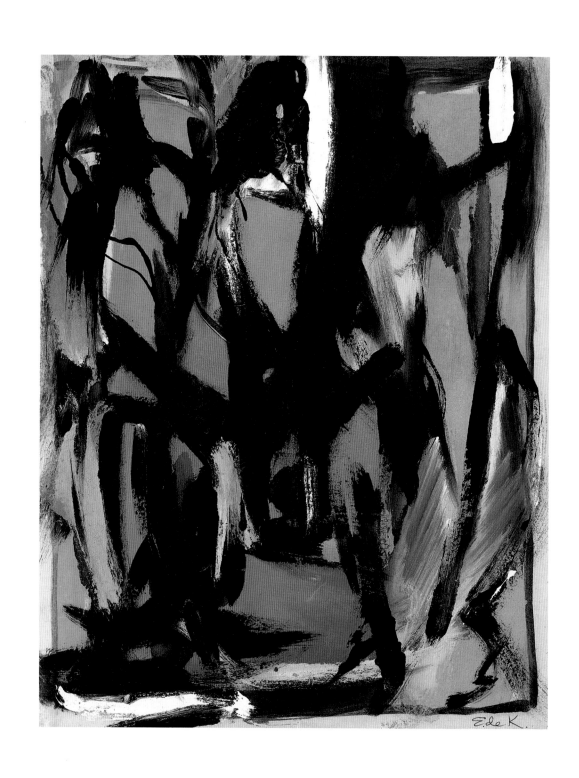

ELAINE DE KOONING *Untitled* 14 x 11" oil on canvas, 1950

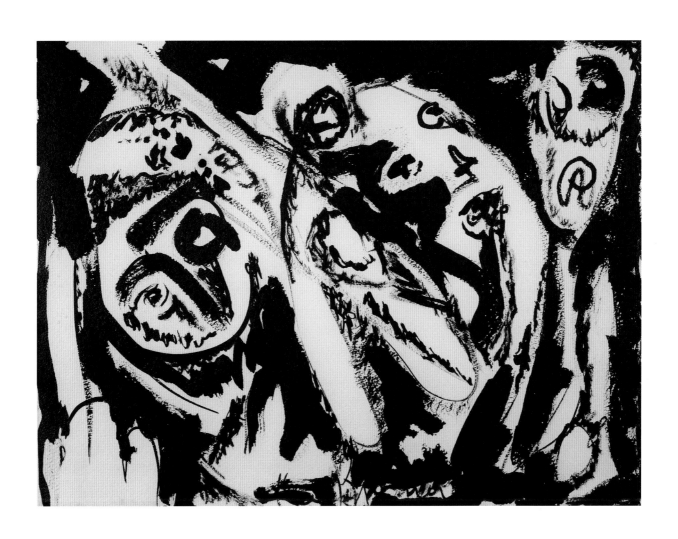

LEE KRASNER *Untitled* 12 x 16" India ink on paper, c. 1951–53 67

ROBERT MOTHERWELL *Drawing* 11¼ x 14½" oil and colored pencil on paper, 1958

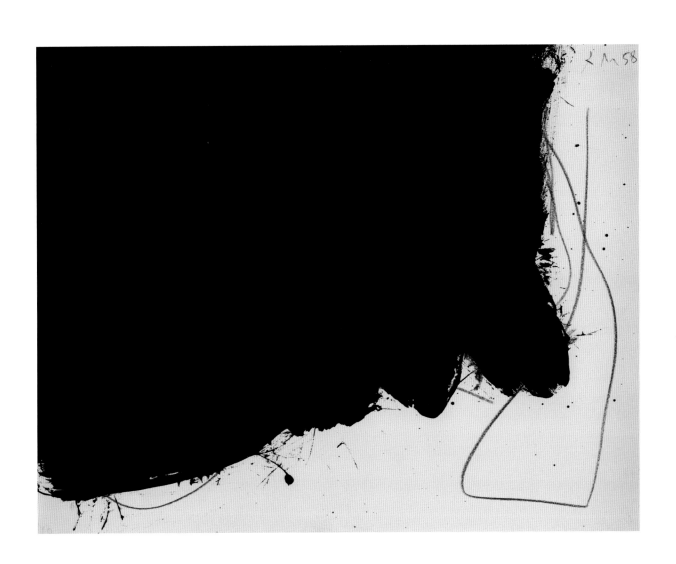

J O N S C H U E L E R *o/c 53–4 Black Light* 89³/₄ x 79³/₄" oil on canvas, 1953

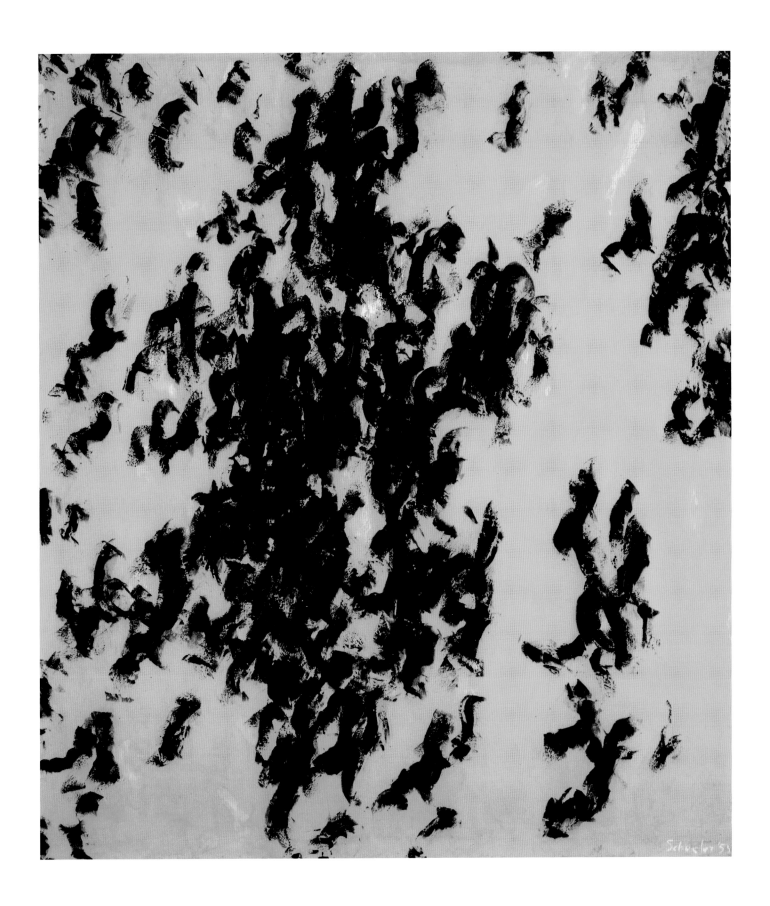

J O H N S A C C A R O *Untitled* 54 x 54" oil on canvas, 1958

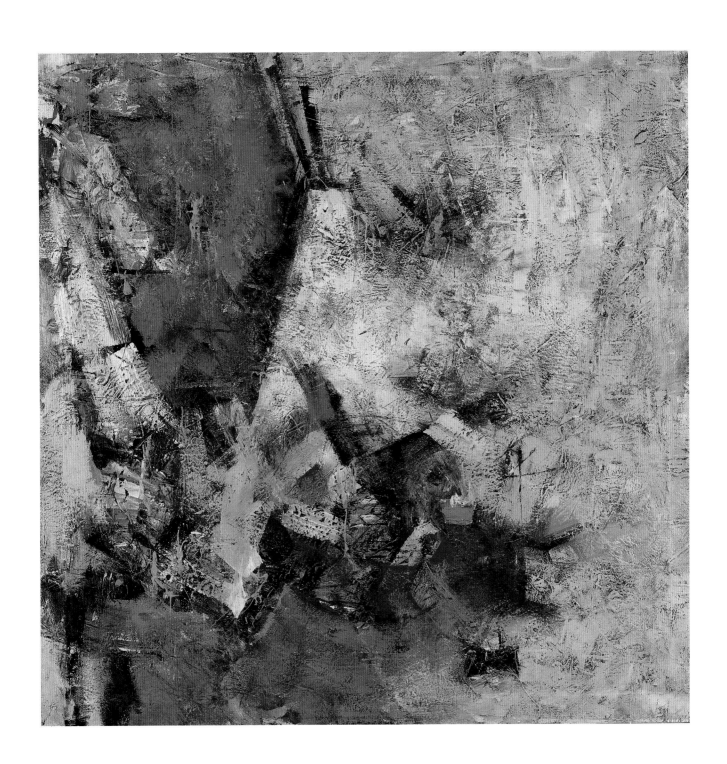

JOAN MITCHELL *Untitled* 19 ¼ x 16" oil on canvas, 1953

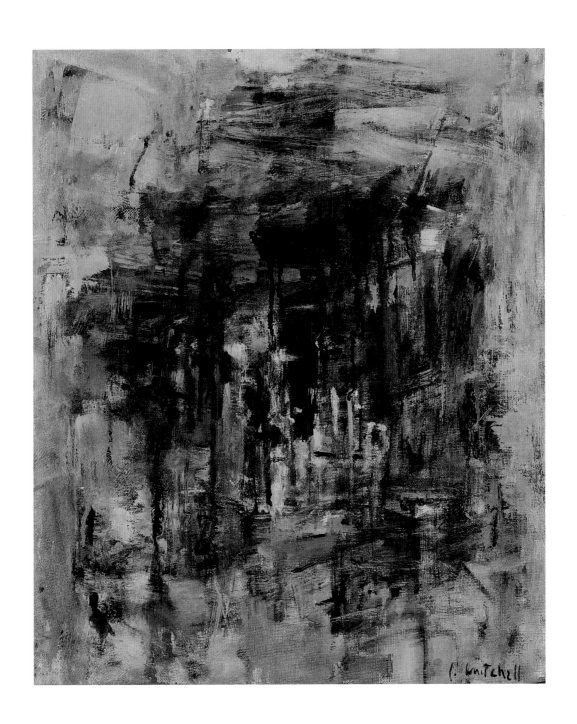

JACK TWORKOV *Trio* 44 x 38" oil on canvas, 1957

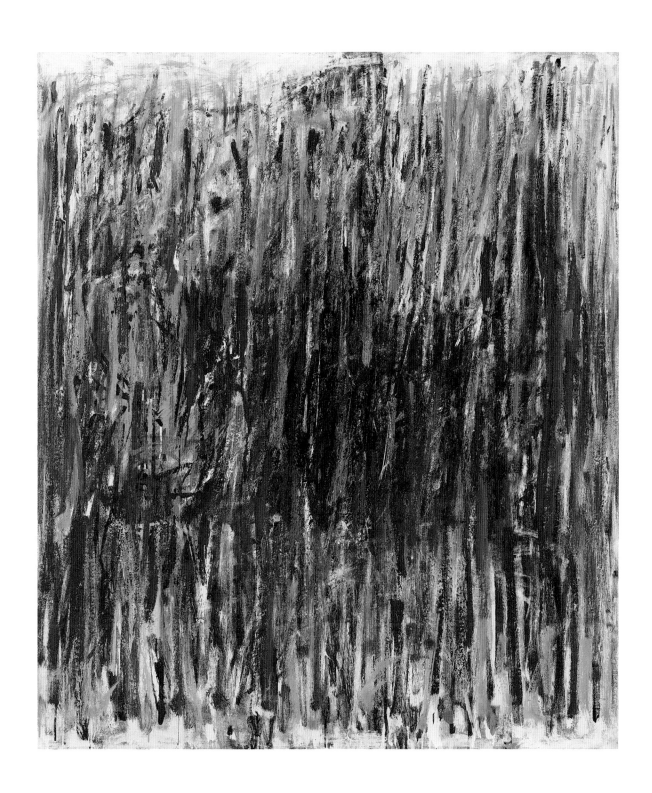

WILLEM DE KOONING *Woman in a Rowboat* 12 x 9" pencil on paper, c. 1960s

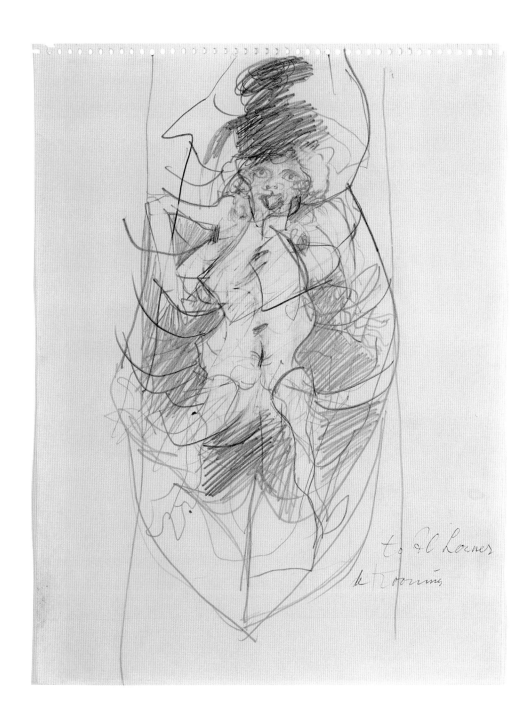

to &l Louner
de Rooning

LARRY RIVERS *Self-Portrait* 24 3/4 x 19" charcoal, pastel, graphite, and wash on paper, 1953

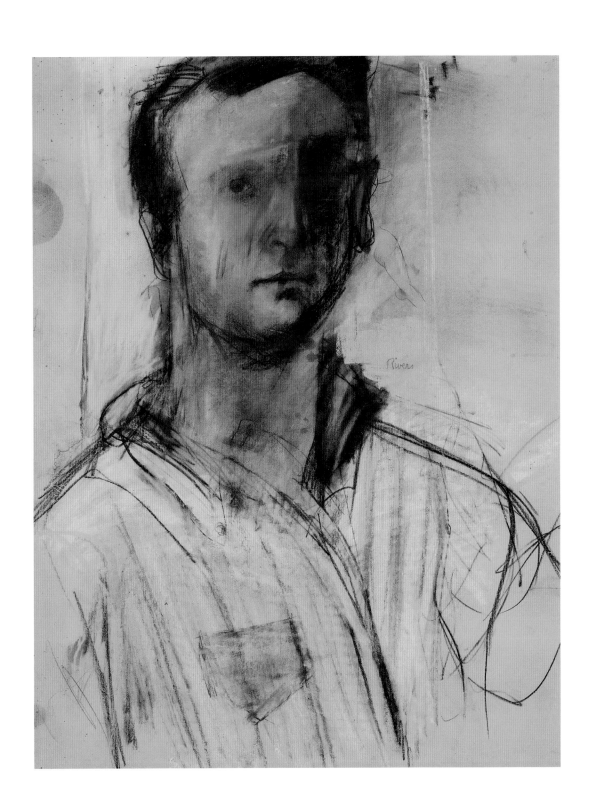

N A T H A N O L I V E I R A *Standing Man III* 42$\frac{1}{4}$ x 40$\frac{1}{4}$" oil on canvas, 1960

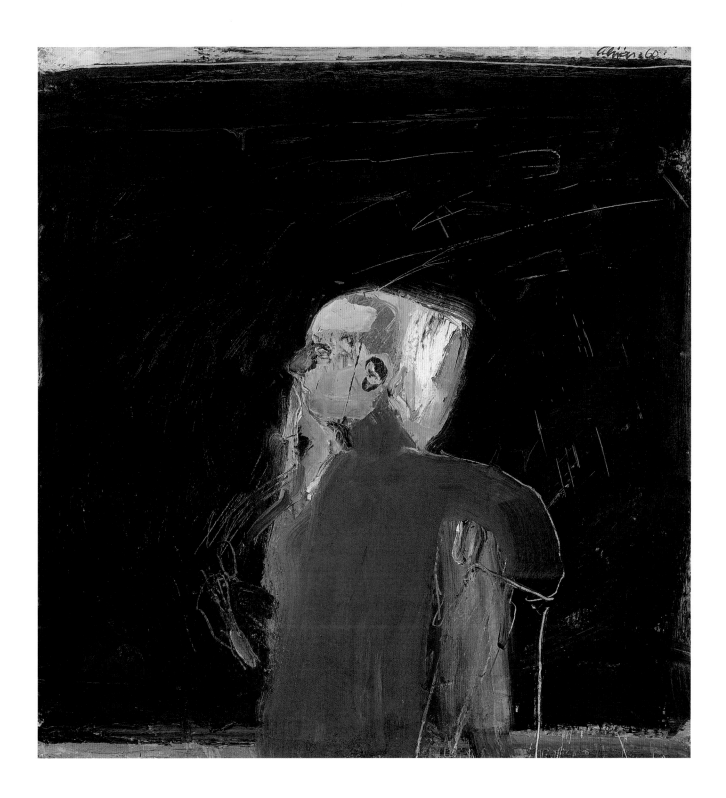

PAUL WONNER *Model Against Light* 17 1/2 x 11 1/2" gouache on paper, 1964

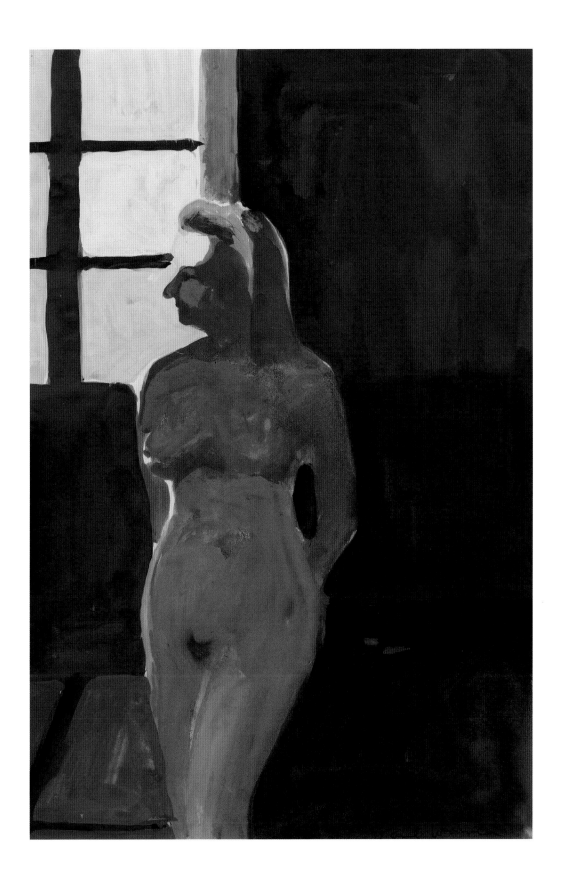

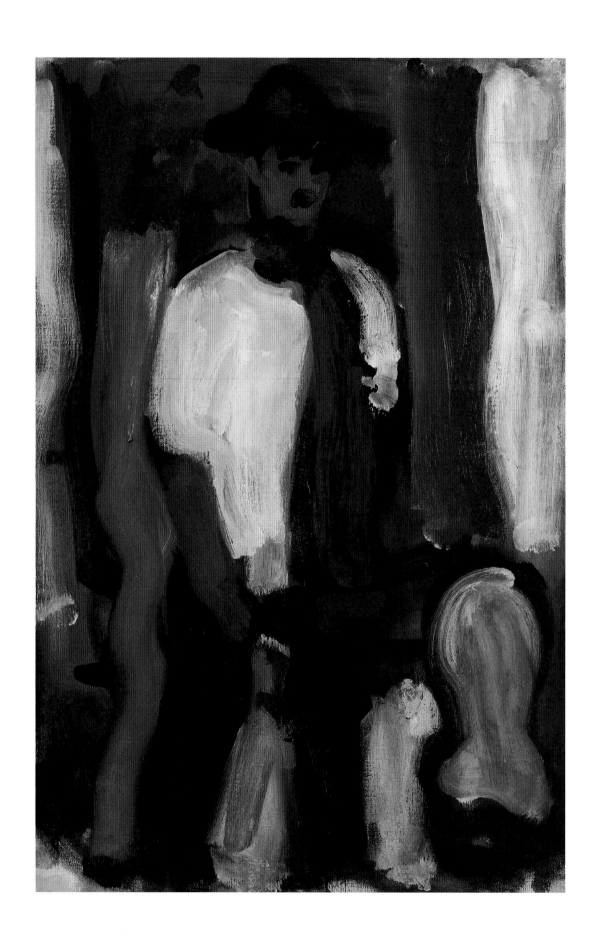

ROBERT DE NIRO, SR. *Yellow Shirt, Blue Scarf* 36 x 24" oil on canvas, n.d.

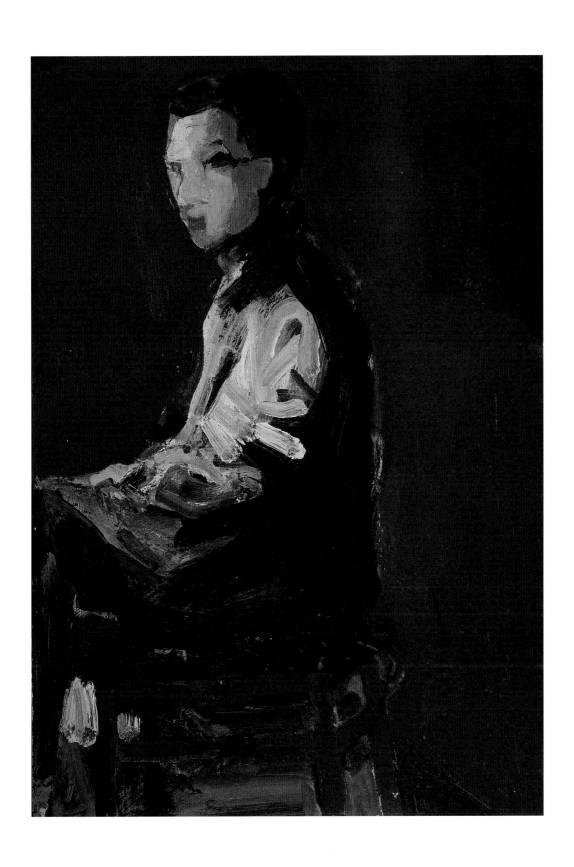

WILLIAM THEOPHILUS BROWN *Man Seated on Red Chair* 17½ x 12¼" oil on panel, 1962

RICHARD DIEBENKORN *Man's Head* 15 3/4 x 9" oil on masonite, 1958

ELMER BISCHOFF *Woman in Bathrobe* 24 x 20" oil on canvas, 1958

D A V I D P A R K *Head of Lydia* 25 x 24" oil on canvas, 1953

MANUEL NERI *Carla V* 67 x 22 ¼ x 20" plaster with oil-based enamel, graphite, wood, wire, and burlap, 1964

R O L A N D P E T E R S E N *An American Picnic* 49$^3/_4$ x 71$^3/_4$" oil on canvas, 1961

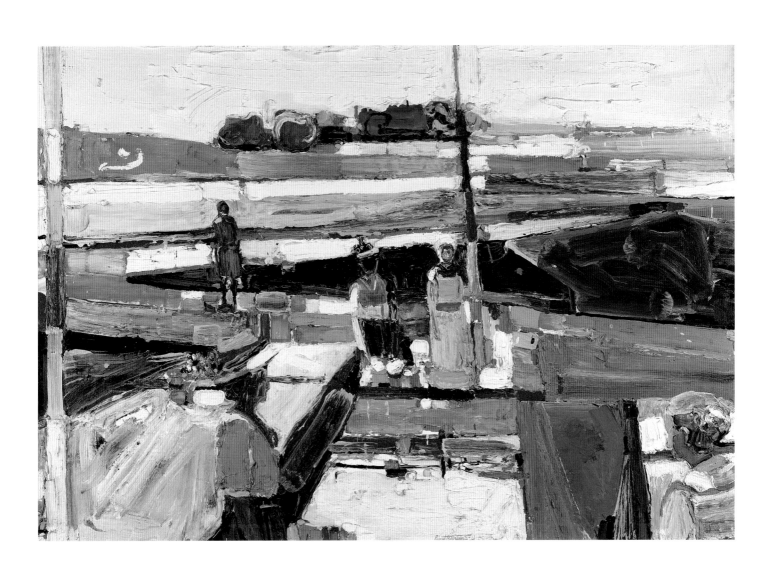

A L E X K A T Z *Ada / Green Glasses* 10 x 9³/₄" oil on aluminum panel cut out, c. 1976

ANDY WARHOL *Untitled (Occupations)* 13 3/4 x 17 5/8" ink, graphite, and gouache on paper, c. 1950s

WAYNE THIEBAUD *Antique Coin Machine* 38 1/4 x 30" oil on canvas, 1957

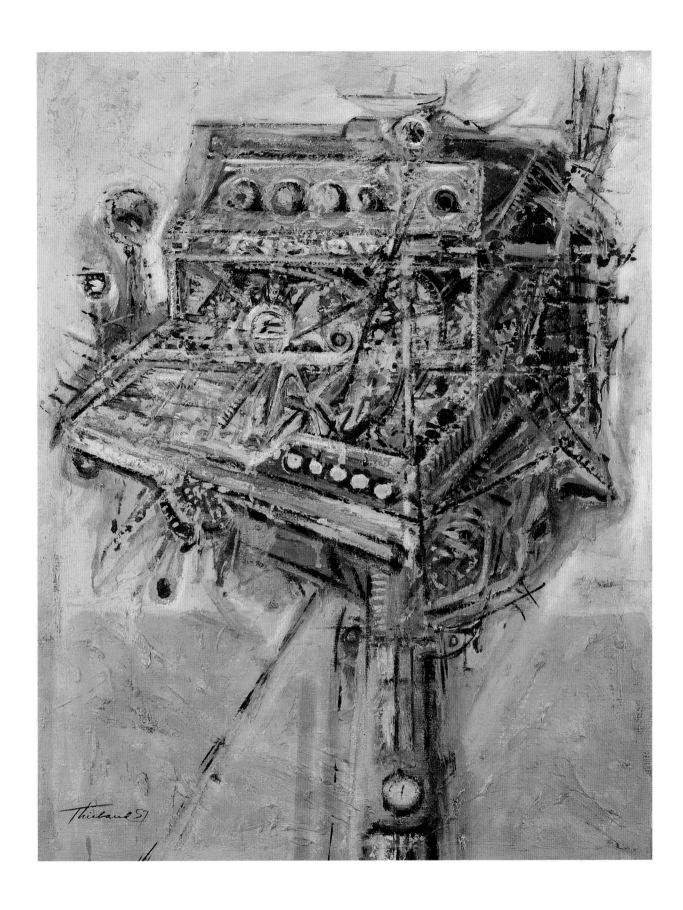

JOSEF ALBERS (1888–1976)

Born in Bottrop, Germany (1888). Works as a schoolteacher in Westphalia (1908–13). Trains to be an art teacher at Königliche Kunstschule, Berlin (1913–15). Works as a printmaker in Essen (1916–19). Studies at Königliche Bayerische Akademie der Bildenden Kunst (1919). Studies and later teaches at Bauhaus, Weimar; initially works with glass and metal, later designs furniture and typography (1920–33). Moves to United States to teach at Black Mountain College, Asheville, NC, on recommendation of Philip Johnson; students include Kenneth Noland, Robert Rauschenberg, among many others (1933–49). Visits Mexico for the first time (1935). Has first solo show at J. B. Neumann's New Art Circle, New York; founding member of American Abstract Artists (1936). Begins *Homage to the Square* series—paintings of squares within squares of flat but vibrant colors that create subtle spatial illusions and that presage op art (1949–76). Appointed chairman of Department of Design, Yale University, New Haven, CT (1950–60). Publishes *Interaction of Color*, a treatise on color theory informed by *Homage to the Square* (1963) and *Despite Straight Lines* (posthumous, 1977). Museum of Modern Art, New York, organizes major solo exhibition that travels to South America, Mexico, and United States (1965–67). Receives first solo exhibition given to a living artist at Metropolitan Museum of Art, New York (1971). Dies in New Haven (1976). Guggenheim Museum, New York, organizes "Josef Albers: A Retrospective" (1988).

MILTON AVERY (1893–1965)

Born in Altmar, NY (1893). Moves to Connecticut and works in manufacturing (1901–04). Attends classes at Connecticut League of Art Students and School of the Art Society of Hartford but remains primarily self-taught (1905–19). Continues to work and paint part-time (1920–24). Becomes a member of Connecticut Academy of Fine Arts (1924). Moves to New York; increases familiarity with European modernism, most notably Matisse (1925). Attends classes at Art Students League (1926–38). Marries commercial illustrator Sally Michel, whose work allows him to paint full-time (1926). Starts exhibiting (1927). Meets and exhibits with Mark Rothko, whose work is influenced significantly by Avery's (1928). Duncan Phillips purchases *Winter Riders* (1929). Daughter March born (1932). First solo exhibition at Valentine Gallery, New York (1935). Joins Paul Rosenberg & Co. Gallery, New York (1943–49). First solo museum exhibition at Phillips Memorial Gallery, Washington, D.C. (1944). "My Daughter, March" exhibition at Durand-Ruel Galleries, New York (1947). Works with monotype, lithography, and woodcuts (1949–55). Joins Grace Borgenicht Gallery, New York (1951). Visits Europe for the first time; museum retrospective held at Baltimore Museum of Art (1952). Executes first large-format canvas; Clement Greenberg publishes major article in *Arts* magazine (1957). Retrospective at Whitney Museum of American Art, New York (1960). *Milton Avery: Paintings: 1930–1960* by Hilton Kramer is published (1962). Dies in New York (1965). Posthumous solo exhibitions include Smithsonian Institution, Washington, D.C. (1969), and Whitney Museum (1982).

ELMER BISCHOFF (1916–1991)

Born in Berkeley, CA (1916). Studies at University of California, Berkeley (BA 1938; MA 1939). Serves in U.S. Air Force, England, during World War II (1942–45). Teaches at California School of Fine Arts, San Francisco (1946–52), and UC Berkeley (1946–47). Receives first solo exhibition at California Palace of the Legion of Honor, San Francisco (1947). Paints abstractions (mid-1940s–early 1950s). Resigns from CSFA to protest Hassel Smith's dismissal, Douglas MacAgy's departure, and Ernest Mundt's appointment as director; begins painting representationally; places emphasis on the figure (1952). Moves to Marysville, CA, to teach at Yuba College; three-year period is extremely productive (1953–56). Exhibits at Paul Kantor Gallery, Los Angeles (1955). Works from models in drawing sessions with Richard Diebenkorn and, periodically, William Theophilus Brown, Nathan Oliveira, James Weeks, and Paul Wonner (mid-1950s). Solo exhibition of figurative paintings at CSFA (1956). Resumes teaching at CSFA under administration of Gurdon Woods (1956); appointed chairman of fine arts department (1957–59). Six works included in seminal "Contemporary Bay Area Figurative Painting" exhibition curated by Paul Mills at Oakland Museum (1957). Becomes head of graduate program at San Francisco Art Institute, formerly CSFA (1959–63). Receives Ford Foundation Grant and takes one-year sabbatical to paint full-time (1959). Begins exhibiting with Staempfli Gallery, New York (1960). Has solo exhibition at M. H. de Young Memorial Museum, San Francisco (1961). Resigns from San Francisco Art Institute and teaches at UC Berkeley (1963–85). Starts

painting large, acrylic abstractions that are informed by surrealism, specifically that of Miró (early 1970s). "Elmer Bischoff 1947–85," a major traveling retrospective, opens at San Francisco Museum of Modern Art (1985–86). Becomes member of National Academy of Design, New York, (1986) and American Academy and Institute of Arts and Letters, New York (1988). Dies in Berkeley (1991). Oakland Museum of California organizes major traveling retrospective and monograph (2001–03).

ERNEST BRIGGS (1923–1984)

Born in San Diego, CA (1923). Joins U.S. Army Signal Corps (1943–46). Studies at Rudolph Schaeffer School of Design, San Francisco (1946–47). Attends California School of Fine Arts, San Francisco, under Mark Rothko, Ad Reinhardt, and Clyfford Still; Still is a major influence on work (1947–51). Co-founds Metart Gallery, a cooperative exhibition space founded in reaction to the institutional art annuals sponsored by San Francisco Museum of Art; gallery sets precedence for San Francisco tradition of artist-run galleries (1949). Has first solo exhibition at Metart; paintings demonstrate influence of Still, Rothko, and Robert Matta (1949). Moves to New York at urging of Edward Dugmore and reestablishes close ties with Jon Schueler and Still (1953). Mature style evolves; works paintings with palette knife and employs either intense colors—red, black, yellow, and sienna—or a pale, delicate grisaille (1952–53). Exhibits at California Palace of the Legion of Honor, San Francisco (1953). Numerous solo exhibitions at Stable Gallery, New York (1954–55). Included in Dorothy Miller's "Twelve Americans" exhibition at Museum of Modern Art, New York (1956). Included in Whitney Museum of American Art Annuals, New York (1955–56, 1961). Teaches at University of Florida, Gainesville (1958); Pratt Institute, New York (1961–84); and Yale University School of Art and Architecture, New Haven, CT (1967–68). Exhibits frequently in gallery and museum exhibitions on both coasts (1960s–70s). Dies in New York (1984). Posthumous retrospectives include Gruenebaum Gallery (1984), Anita Shapolsky Gallery (2001), and Mishkin Gallery, Baruch College, all New York (2002). Work is included in major museum collections, including San Francisco Museum of Modern Art, Oakland Museum of California, and Whitney Museum.

> "My aim in painting is to create pulsating, luminous, and open surfaces that emanate a mystic light, in accordance with my deepest insight into the experience of life and nature." —Hans Hofmann

JOAN BROWN (1938–1990)

Born Joan Beatty in San Francisco (1938). Attends California School of Fine Arts, where Elmer Bischoff is an important mentor (BFA 1959, MFA 1960). Marries William H. Brown (1956). Takes studio on Fillmore Street, San Francisco, next door to fellow artists Wally Hedrick and Jay DeFeo; first solo exhibition at Six Gallery, San Francisco (1957); Meets New York dealer George Staempfli, who purchases paintings and offers exhibition; starts living with Manuel Neri (1959). First solo exhibition at Staempfli Gallery, New York, at age 22 (1960). Executes ten monumental collages (1964). Marries Neri after marriage to Brown is annulled; son Noel Neri is born; receives Outstanding Single Achievement in Art award from *Mademoiselle* magazine (1962). Stops working in heavy, expressionist style; starts painting in a more representational manner using very autobiographical and, later, spiritual imagery (mid-1960s). Divorces Neri (1966) but remains close to him. Included in Peter Selz's landmark "Funk" exhibition at Berkeley Art Museum (1967). Marries artist Gordon Cook (1968–76). Solo exhibition at San Francisco Museum of Modern Art (1971). Joins faculty of Academy of Art, San Francisco (1971–74). Begins long association with Allan Frumkin Gallery, New York (1974–86; later Frumkin/Adams Gallery, New York). Teaches at University of California, Berkeley (1974–90). Marries Michael Hebel (1980–90). Dies in Proddatur, India (1990). Major posthumous retrospective and monograph organized by Oakland Museum of California and Berkeley Art Museum (1998).

WILLIAM THEOPHILUS BROWN (1919–)

Born in Moline, IL (1919). Attends Yale University (BA Music 1941). Serves in U.S. Army (1941–45). Travels throughout Europe and studies with Fernand Léger, Paris, and Amédée Ozenfant, New York (1946–49). Moves to New York and befriends Philip Guston, Mark Rothko, and Willem and Elaine de Kooning; Willem de Kooning and Roberto Matta become lasting influences (1949–50). Moves to Berkeley to study painting at University of California, Berkeley; meets Richard Diebenkorn and future life partner Paul Wonner (1952–53; MA 1953). Teaches drawing and painting at California School of Fine Arts, San Francisco; participates in figure drawing sessions with Elmer Bischoff, David Park, Richard Diebenkorn, James Weeks, and others (1955–57). *Football* paintings published in *Life* magazine (1956). Appointed lecturer at University of California, Davis (1957–58). First solo show at Felix Landau Gallery, Los Angeles (1958). Travels to Europe; work becomes more surrealist and melancholic after seeing works by de Chirico and other Italian Metaphysical painters but continues to work in small-scale format (1959). First solo New York exhibition at Barone Gallery (1961). Moves to Santa Monica, then Malibu, CA (1961–62); lives in Southern California until 1974. Returns to Berkeley and teaches at UC Davis (1975–76). Works abstractly, creating a series of collages that utilize peeled paint arranged in geometric compositions (2000–). Currently lives and works in San Francisco.

GIORGIO CAVALLON (1904–1989)

Born in Sorio, Vicenza, Italy (1904); family immigrates to United States (1906). Returns to Italy after death of his mother (1910); returns to United States at age 16 (1920). Attends National Academy of Design, New York (1926–30); studies with Charles W. Hawthorne in Provincetown, MA (1927). Receives Louis Comfort Tiffany grant (1929). Moves to Italy during Depression (1929–32). Exhibits at Venice Biennale and Bottega d'Art, Vicenza, Italy (1932). Returns to New York and meets Hans Hofmann (1933). Attends Hofmann's school in New York; begins studying Mondrian and Jean Hélion (1934–36). Receives solo exhibition at A.C.A. Gallery, New York (1934). Joins Works Progress Administration Federal Art Project; works as assistant to Arshile Gorky (mid-1930s). Starts painting loosely brushed, abstract paintings based on the grid that aim for a harmonious balance of volume, shape and color (late 1930s). Co-founder and member of American Abstract Artists organization (1936–57). A charter member of "The Club," a group of abstract expressionists who regularly attend the Cedar Bar; participates in the group's "Ninth Street Show." Exhibits in New York at Egan Gallery (1946–54) and Stable Gallery (1957, 1959). Included in Whitney Museum Annual, Whitney Museum of American Art, New York (1959, 1961, 1965), and Kootz Gallery, New York (1961, 1963, 1965). Begins association with Gruenebaum Gallery, New York (1977–88). Solo exhibition at Neuberger Museum, Purchase, NY (1977). Dies in New York (1989). Posthumous solo exhibitions at William Benton Museum of Art, Storrs, CT (1990), and New Britain Museum of American Art, New Britain, CT (1994).

> "Part of painting is physical. Another part is intellectual. The most highly prized aspect is intuitive, when it is operative. The percentage changes with each painting. There should be a balance."
>
> —Richard Diebenkorn

EDWARD CORBETT (1919–1971)

Born in Chicago (1919). Family settles in San Francisco Bay Area (1934). Attends California School of Fine Arts, San Francisco (1936–41). Serves in Merchant Marine Corps (1941–44). Lives and paints in New York; befriends Ad Reinhardt and joins Communist Party (1944–46). Returns to San Francisco and later joins Abstract American Artists (1946). First solo exhibition at Pat Wall Gallery, Monterey, CA. Teaches at CSFA and University of California, Berkeley, where one of his students is Sam Francis (1947–50). Lives with Robert McChesney, Hassel

Smith, sculptor Mary Fuller, and poet Weldon Kees in Point Richmond, CA (late 1940s). Begins *Black Paintings*, a series of refined monochromatic works that use rich, dark blacks produced by combining oil and enamel layered on top of one another; they are intended to be protest works in response to McCarthyism. The paintings have profound influence on Reinhardt (1950). Resigns from CSFA to protest Hassel Smith's dismissal (1950). Receives Abraham Rosenberg Fellowship and travels in Southwest; moves to Taos, NM, and teaches at University of New Mexico (1951). Creates series of charcoal drawings notable for their subtle tonal ranges (1951–54); drawings included in Museum of Modern Art, New York, exhibition (1952). Included in Whitney Museum of American Art Annuals and Biennials, New York (1953, 1954–56, 1958, 1961, 1963, 1965). First solo New York exhibition at Grace Borgenicht Gallery (1954). Rejects New York and takes teaching position at Mount Holyoke College, South Hadley, MA (1953–63). Begins *Paintings for Puritans* series, a set of white-on-white abstractions (1955). Starts working with color and painting luminous abstract works (late 1950s). Retrospective at Massachusetts Institute of Technology, Cambridge (1961). Exhibitions at Walker Art Center, Minneapolis (1961), and San Francisco Museum of Modern Art (1969). Lives and paints in Washington, D.C. (1964–71). Teaches at University of California, Santa Barbara (1967–68). Dies in Provincetown, MA (1971). Posthumous exhibition at Richmond Art Center, Richmond, CA (1990).

ELAINE DE KOONING (1918–1989)

Born Elaine Fried in Brooklyn, NY (1918). Attends Hunter College, New York (1936). Attends classes at Leonardo da Vinci Art School, New York, and studies with Conrad Marca-Relli (1937). Meets Willem de Kooning and transfers to American Artists School; de Kooning is an important mentor and influence (1937). Begins painting cityscape series of drawings and watercolors (1938). Starts painting portraits of friends and associates such as Leo Castelli and Merce Cunningham (1940s). Marries Willem de Kooning (1943). Spends summer at Black Mountain College, Asheville, NC; starts writing art reviews for *ARTnews*; paints sports pictures based upon magazine and newspaper photographs (1948). Receives first solo exhibition at Stable Gallery, New York (1954); begins working on series of abstractions based on current events. Separates from de Kooning (1957). Takes first of many teaching appointments at University of New Mexico, Albuquerque; starts painting horizontally in response to landscape; palette becomes bolder and brighter; sees bullfights in Ciudad Juarez, Mexico (1958). Accepts commission to paint presidential portrait of President John F. Kennedy (1963). Reconciles with de Kooning and moves to Springs, Long Island, NY (1975). Travels to Paris and begins *Bacchus* series after seeing a statue in the Luxembourg Gardens, Paris (1976). Sees Paleolithic drawings at Lascaux and begins *Cave Paintings* series (1983). Travels to China and Japan; begins making sumi ink wash drawings (1986). Completes first etchings at Crown Point Press, San Francisco (1987). Dies in Southampton, NY (1989). *Untitled #15 (Black Mountain)*, one of seventeen canvases done at Black Mountain but never exhibited before 1989, is purchased by Metropolitan Museum of Art, New York.

WILLEM DE KOONING (1904–1997)

Born in Rotterdam, The Netherlands (1904). Attends Rotterdam Academy of Fine Art and works as a commercial art apprentice (1916–24). Immigrates to United States and settles in Hoboken, NJ, and works as a house painter (1926). Moves to New York and meets John Graham and Arshile Gorky (1927). Begins painting still life and figure compositions informed by cubism and surrealism (1928). Joins the Artist's Union, New York (1934). Works on Works Progress Administration Federal Art Project and meets Stuart Davis (1935–37). Begins painting full-time; included in "New Horizons in American Art" at Museum of Modern Art, New York (1936). Shares a studio with Arshile Gorky (1939). Marries Elaine Fried (1943). Begins using household enamels to paint black-and-white abstractions (1946–50). Receives first solo show at Egan Gallery, New York (1948). Teaches at Black Mountain College, Asheville, NC (1948), and Yale School of Art, New Haven, CT (1950–51). Art Institute of Chicago acquires *Excavation*; included in Venice Biennale (1950). Exhibits *Women* paintings, including *Woman I*, at Sidney Janis Gallery, New York (1953). Separates from Elaine de Kooning (1957). Begins merging the female figure and landscape (mid- to late 1950s). Works on *Abstract Landscape* series (1960s). Begins making bronze sculptures (1969). Moves to Springs, Long Island, NY (1963). Receives Presidential Medal of Freedom (1964). Receives first retrospective at Stedelijk Museum, Amsterdam (1968). Executes first sculpture while staying in Rome (1969). Walker Art Center, Minneapolis, organizes traveling exhibition of drawings and sculpture (1974). Reconciles with Elaine de Kooning (1975). Smithsonian Institution, Washington, D.C., and Solomon R. Guggenheim Museum, New York,

mount major solo exhibitions (1976; 1978). Work becomes increasingly lyrical and calligraphic (early 1980s). Receives U.S. National Medal of Arts (1985). San Francisco Museum of Modern Art organizes major retrospective of late-period paintings that travels to Museum of Modern Art; dies in East Hampton, NY, same year (1997).

ROBERT DE NIRO, SR. (1922–1993)

Born in Syracuse, NY (1922). Takes art classes at Syracuse Museum during high school (1933–37) and later studies with etcher Ralph Pearson (1938). Studies with Hans Hofmann in Provincetown, MA (1939). Attends Black Mountain College, Asheville, NC, at age 18 and studies under Josef Albers (1939–40). Moves to New York to study with Hans Hofmann, who becomes a major influence (1941–42). Marries artist Virginia Admiral (1942). De Niro and Admiral establish a studio in Greenwich Village; friends include Anaïs Nin, Henry Miller, and Tennessee Williams (1940s). Son Robert De Niro, Jr. born; Admiral and De Niro separate (1943). Receives first solo exhibition at Peggy Guggenheim's gallery Art of This Century, New York (1946). Exhibits at Charles Egan Gallery, New York (1950–54). Joins Zabriskie Gallery, New York (1958–70). Moves to Paris and meets Joseph Hirshhorn, who becomes a major benefactor, purchasing fifty works (1960–64). Teaches summer sessions at State University of New York, Buffalo, and at Cooper Union, New York, and School of Visual Arts, New York (1976–75). Receives Guggenheim Fellowship (1968). Lives in San Francisco; completes large body of landscapes (1977–79). Exhibits with Charles Campbell Gallery, San Francisco (1978–79). Solo exhibition at Mint Museum and Asheville Art Museum, Charlotte, NC (1981). Dies in New York (1993). Posthumous exhibits held at Galleria Nazionale d'Arte Moderna, Rome (2004–05), and La Piscine Musée d'Art et d'Industrie André Diligent, Roubaix, France (2005). Salander-O'Reilly publishes major monograph (2005). Works included in the collections of Corcoran Gallery of Art, Washington, D.C., Hirshhorn Museum and Sculpture Garden, Washington, D.C., Metropolitan Museum of Art, New York, Oakland Museum of California, and Whitney Museum of American Art, New York.

RICHARD DIEBENKORN (1922–1993)

Born in Portland, OR (1922). Family moves to San Francisco (1924). Attends Stanford University (1940–43, BA 1949). Studies at University of California, Berkeley (1943). Serves in U.S. Marine Corps during World War II (1943–45). Attends California School of Fine Arts, San Francisco (1946). Sees Clyfford Still's exhibition at California Palace of the Legion of Honor, San Francisco, which inspires Diebenkorn to move to larger canvases (1947). Lives in Sausalito, CA, and teaches at CSFA (1947–50). Receives first solo show at California Palace of the Legion of Honor (1948). Studies at University of New Mexico, Albuquerque (MFA 1951); continues to paint abstractly. Sees Matisse retrospective at Los Angeles Municipal Art Gallery; moves to Urbana to teach at University of Illinois for one year (1952). Moves to New York and meets Clement Greenberg and Willem de Kooning (1953). Returns to San Francisco and begins *Berkeley* series of abstract expressionist paintings (1953). Begins painting still lifes, then landscapes as a prelude to figurative painting; participates in drawing sessions with Elmer Bischoff, David Park, and others (1955). First New York solo show at Poindexter Gallery (1956). Five works included in seminal "Contemporary Bay Area Figurative Painting" exhibition curated by Paul Mills at Oakland Museum (1957). Teaches at California College of Arts and Crafts, Oakland (1955–57), and at San Francisco Art Institute, formerly CSFA (1959–63). Figurative paintings become more geometric with flatter planes of color (1965). Lives in Santa Monica and teaches at University of California, Los Angeles (1966–73). Paints last figurative canvas and begins *Ocean Park* paintings, a series of 140-plus monumental abstractions inspired by views of his Santa Monica neighborhood. (1967). Represents United States at Venice Biennale (1978). Moves to Healdsburg, CA (1988). Begins painting heraldic symbols like spades in gouache and collage (late 1980s). Receives major retrospectives at Whitney Museum of American Art, New York (1988), and Whitechapel Art Gallery, London (1991–92). Awarded the National Medal of Art (1991). Dies in Berkeley, CA (1993).

JAMES BUDD DIXON (1900–1967)

Born in San Francisco (1900). Attends University of California, Berkeley (1920–21, 1922–23). Studies at Mark Hopkins Institute of Art, San Francisco (1923–26, 1929), and at California School of Fine Arts, San Francisco, on the G.I. Bill (1946, 1948–49). Establishes storefront studio at 700 Lombard Street, San Francisco, a gathering place for artists (1946); becomes an important figure for second-generation abstract expressionists in San Francisco.

Sees Jackson Pollock's solo show at San Francisco Museum of Art, which greatly informs later work (1945). Teaches printmaking at CSFA (1950–55) and painting at San Francisco Art Institute, formerly CSFA (1961–65). Dies in San Francisco (1967). Works included in the collections of Smithsonian American Art Museum, Washington, D.C.; Dallas Museum of Art; Fine Arts Museums of San Francisco; and Oakland Museum of California, among others. Posthumous exhibitions include "The San Francisco School of Abstract Expressionism," Laguna Art Museum, Laguna Beach, CA (1996); "California Abstract Expressionists: Prints from the Charles R. Bean Collection," International Print Center, New York (2003); and "While Pollock Was Sleeping: Bay Area Abstract Expressionists from the Blair Collection," Laguna Art Museum (2005).

HERBERT FERBER (1906–1991)

Born in New York City (1906). Attends dental school at Columbia University, New York, where he learns to draw anatomically (DDS 1930) and night classes at Beaux-Arts Institute of Design, New York, a free school for academic architectural sculptors (1926). Attends National Academy of Design, New York, and receives scholarship to work at Tiffany Foundation in Long Island, NY (1930). Carves wood and stone sculptures, informed by Aristide Maillol, William Zorach, and pre-Columbian and African art (1931–44). Travels to Europe and sees Romanesque sculptures (1938). Receives first solo exhibition at Midtown Galleries, New York (1937). Begins working with welded metal, leading to lighter, more open expressions (1944). Meets Adolph Gottlieb, Mark Rothko, Robert Motherwell, and Willem de Kooning (late 1940s). First exhibition at Betty Parsons Gallery, New York; Barnett Newman writes the catalogue essay (1948–49). Eliminates sculptural bases from his work (1950–52) and explores idea of freestanding and hanging sculpture. *Spheroid I* wins award for monument to unknown political prisoner (1953). Begins making "roofed" sculptures in which organic forms are contained by a cagelike framework (1954). Roof sculptures grow to large-scale and become known as "environments." Begins painting large canvases (1958). Begins using Cor-ten steel (1960). Exhibits *Sculpture as Environment* at Whitney Museum of American Art, New York (1961); Walker Art Center, Minneapolis (1962); and Museum of Fine Art, Houston (1981). Starts *Homage to Piranesi* series (1961). Begins spending most of his time painting canvases and multicolored reliefs (1970s). Is named Mellon Chair in Humanities Visiting Professor at Rice University, Houston (1979). Dies in North Egremont, MA (1991). Solo exhibitions mounted at Colgate University, Hamilton, NY, and at Knoedler & Company, New York (1998, 2001, 2005).

SAM FRANCIS (1923–1994)

Born in San Mateo, CA (1923). Studies psychology and medicine at University of California, Berkeley (1941–43). Serves in U.S. Army Air Corps (1943–45); begins painting in San Francisco Veterans Hospital while recuperating from spinal injuries incurred by a plane crash (1943–47). Starts exploring expressive abstraction and studies privately with David Park (1948–50). Returns to UC Berkeley as an art major (BA 1949, MA 1950); studies with Edward Corbett and experiments with surrealism and abstract expressionism as practiced by Mark Rothko and Clyfford Still (1949). Moves to Paris; attends Atelier Fernand Léger and meets Jean-Paul Riopelle, who becomes an important influence (1950). Begins producing monochromatic paintings of transparent layers of color; work is particularly informed by Monet's waterlilies series (early 1950s). Receives first solo show at Galerie Nina Dausset, Paris (1952); subsequent Parisian exhibitions at Galerie Rive Droite (1956–70). Included in "Twelve Americans" exhibition at Museum of Modern Art, New York (1956). Spends two months in Japan; the experience influences his works as white space and asymmetrical composition take on increasing importance (1957). Begins association with Martha Jackson Gallery, New York (1957). Solo exhibitions at Phillips Gallery, Washington, D.C. (1958) and San Francisco Museum of Art (1959, 1967). Receives first European retrospective at Kunsthalle Berne, Switzerland (1960). Returns to California (1960); color blue begins to dominant paintings, as seen in *Blue Balls* series (1960–62). Begins long association with André Emmerich Gallery, New York, 1969–89). Lives in Santa Monica, CA, and works primarily in watercolor and lithography (1962–94). Teaches at San Francisco Art Institute, formerly CSFA (1966). Paintings feature perpendicular grids (late 1970s); later introduces looser, more calligraphic element (1980s). Donates ten major works to Museum of Contemporary Art, Los Angeles (1993). Dies in Santa Monica, CA (1994). Posthumous retrospectives at Los Angeles County Museum of Art (1995) and Museum of Contemporary Art, Los Angeles (1999).

HELEN FRANKENTHALER (1928–)

Born in New York City (1928). Studies under Rufino Tamayo at Dalton School, New York, and later with Paul Feeley at Bennington College, VT (BA 1949). Moves to New York and studies with Hans Hofmann and Vaclav Vytlacil at the Art Students League; meets Clement Greenberg, who becomes her mentor and introduces her to David Smith, Jackson Pollock, Lee Krasner, and Willem de Kooning (1950). Begins painting on unprimed canvases using thin washes of paint that soak and stain the ground (early 1950s). Receives first solo exhibition at Tibor de Nagy Gallery, New York (1951). Paints *Mountains and Sea*; this work is major influence on future color field painters, including Morris Louis and Kenneth Noland (1952). Starts working with linear skeins of paint and sun-like shapes (1957). Marries Robert Motherwell (1958–71). Included in "Young America 1957" at Whitney Museum of American Art, New York (1957). Solo exhibitions at Jewish Museum, New York (1960), and Corcoran Gallery of Art, Washington, D.C. (1975). Exhibits steel sculptures and works with woodcuts and color printing (1970s). Elected to American Academy of Arts and Sciences (1991). Receives Jerusalem Prize for Arts and Letters (1999). Retrospectives at Solomon R. Guggenheim Museum, New York (1975, 1985, 1998); Museum of Modern Art, New York (1989–90); National Gallery of Art, Washington, D.C. (1993); and Neue Nationalgalerie, Berlin (2004). Lives in New York and Stamford, Connecticut.

> "I do not want other artists to imitate my work—they do even when I tell them not to—but only my example for freedom and independence from all external, decadent and corrupting influences."—Clyfford Still

JOHN GRAHAM (1886–1961)

Born Ivan Dombrowski in Kiev, Russia, the son of minor Russian aristocrats (1886). Studies law at University of Kiev; later becomes Tsarist officer in Russian cavalry during World War I; captured by the Bolsheviks and briefly imprisoned during Russian Revolution (1917). Escapes to Paris, then comes to New York; changes name to Graham (1920). Enrolls in Art Students League and studies under John Sloan; meets Alexander Calder, Barnett Newman, and Adolph Gottlieb (1921). Starts exhibiting portraits and still lifes; works in a variety of styles, including postimpressionist still lifes to Picasso-inspired studies; meets Cone sisters and Duncan Phillips, who become important patrons (1920s). Exhibits at Whitney Museum of American Art, New York; National Academy of Design, New York; and Pennsylvania Academy of Fine Art, Philadelphia. Begins association with E. Weythe and Dudensing galleries, New York (1926). Receives first solo museum exhibition at Phillips Collection, Washington, D.C. (1929). Exhibits at Zborowski Gallery, Paris; curates collection of African art for *Vanity Fair* editor Frank Crowinshield (1930s). Publishes *System & Dialectics of Art*, which explains his belief in the important role of the subconscious in art and becomes an important treatise for the abstract expressionists, specifically Jackson Pollock (1937). Influential figure in New York artistic circles; curates exhibition at McMillen Gallery, New York, that exhibits Pollock for the first time in New York, alongside Willem de Kooning, Lee Krasner, Picasso, and Matisse (1942). Begins to concentrate solely on portraiture informed by Greco-Roman antiquities and ideals as well as old master painting; exhibits portraits at Rose Fried Gallery, New York (1946). Travels for several years and dies in London (1961). Work is included in the collections of Whitney Museum and Phillips Collection.

MARSDEN HARTLEY (1877–1943)

Born in Lewiston, ME (1877). Moves to Cleveland, OH, and studies art with painter John Semon (1893–96); attends Cleveland School of Art (1898). Moves to New York to study art at William Merrit Chase's New York School of Art; later transfers to National Academy of Design (1899–1904). Returns to Maine periodically (1906–11). Has first solo show at Alfred Stieglitz's 291 Gallery, New York (1909). Begins painting modernist land-

scapes; sees Cézanne's work for the first time (1911–12). Travels to Paris; meets Gertrude Stein and studies works by Wassily Kandinsky and Der Blaue Reiter (1912). Travels to Germany and meets Kandinsky and Franz Marc; exhibits in Berlin (1913). Begins *Amerika* series and *German Officer* paintings; returns to New York because of World War I (1914–15). Travels through North America—Provincetown, Bermuda, New Mexico, Los Angeles, San Francisco—and Europe and paints extensively (1916–28). Publishes *Adventures in the Arts* (1921). *Mont Sainte-Victoire* paintings exhibited at Stieglitz's Intimate Gallery, New York (1929). Receives Guggenheim grant. Moves to Garmisch-Partenkirchen in Bavarian Alps; paints series of landscapes (1933). Works for Works Progress Administration Federal Art Project (1934, 1936). Exhibits *New England* series at Stieglitz's gallery An American Place, New York (1936). Moves to Maine (1937). Paints landscapes, seascapes, and still lifes of Maine and writes poetry (1937–43). Dies in Ellsworth, ME (1943). Posthumous retrospectives include Museum of Modern Art, New York (1944); Whitney Museum of American Art, New York (1980); and Wadsworth Atheneum Museum of Art, Hartford, CT, which travels to Phillips Collection, Washington, D.C., and Nelson-Atkins Museum of Art, Kansas City, MO (2003).

AL HELD (1928–2005)

Born in Brooklyn, NY (1928). Expelled from school at age 16 for chronic truancy (1944); joins U.S. Navy (1945–47). Studies at Art Students League, New York (1948–49) and at Academie de la Grande Chaumiere, Paris, on the G.I. Bill (1950–53). Has first solo show at Galerie Huit, Paris (1952). Returns to New York (1953). Exhibits abstract expressionist works at Poindexter Gallery, New York (1959). Abandons expressionism and starts painting "concrete abstractions" (1960s). Teaches at Yale University, New Haven, CT (1962–1980, 1999–2005). Receives Guggenheim Fellowship (1966). Starts painting black-and-white "spatial conundrums"; develops geometric, linear vocabulary that consists of inscribed circles and thick cubes and prisms (1967–78). Solo exhibition at Whitney Museum of American Art, New York (1974), and Institute of Contemporary Art, Boston (1978). Reintroduces color into paintings (late 1970s). Teaches at American Academy, Rome (1981). Elected to American Academy and Institute of Arts and Letters (1984). Establishes residence in Boiceville, NY, and Camerata, Italy (mid-1990s). Starts working on large-scale commissions, including a mural for the New York City subway system (2005). Dies in Camerata, Italy (2005).

HANS HOFMANN (1880–1966)

Born in Weissenberg, Germany (1880). Attends Academie de la Grande Chaumiere, Paris; deeply influenced by avant-garde, specifically fauvism, cubism, and surrealism (1904–14). First solo exhibition at Paul Cassirer Gallery, Berlin (1910). Returns to Germany and opens Hans Hofmann School of Fine Arts in Munich; students include Louise Nevelson, Carl Holty, and Worth Ryder (1914–15). Marries Maria (Miz) Wolfegg (1924). Comes to California to teach a summer session at University of California, Berkeley, at the invitation of Worth Ryder; returns the following year (1930, 1931). California Palace of the Legion of Honor, San Francisco, mounts first U.S. exhibition of his work (1931). Translates *Creation in Form and Color: A Textbook for Instruction in Art* (1904; 1931). Closes European school and reopens it in New York (1933) and later opens a branch in Provincetown, MA; students include Robert De Niro, Sr., Lee Krasner, Helen Frankenthaler, Larry Rivers, and Frank Stella (1933–58). Paints expressionist portraits and still lifes (1930s–40s). First New York solo exhibition at Peggy Guggenheim's Art of This Century Gallery, New York (1944). Begins association with Kootz Gallery, New York (1947–56). Whitney Museum of American Art, New York, mounts major retrospective (1957). Retires from teaching and begins painting full-time (1958); many of his abstract works explore his "push-pull" theory of color (1950s–60s). Represents United States at XXX Venice Biennale along with Philip Guston, Franz Kline, and Theodore Roszac (1960). Miz Hofmann dies; Museum of Modern Art, New York, organizes traveling retrospective (1963). Marries Renate Schmitz (1964). Bequeaths forty-five paintings to UC Berkeley, leading to creation of Berkeley Art Museum (1963). Paints *Renate* series (1964–66). Dies in New York (1966). Important posthumous exhibitions include "The Renate Series," Metropolitan Museum of Art, New York (1972, 1981); Hirshhorn Museum and Sculpture Garden, Washington, D.C., in conjunction with Museum of Fine Arts, Houston (1976); Tate Gallery, London (1988); and Whitney Museum (1990).

JOHN HULTBERG (1922–2005)

Born in Berkeley, CA (1922). Studies literature at Fresno State College (BA 1939). Serves in U.S. Navy (1943–46), then studies painting with Clyfford Still, Clay Spohn, and Mark Rothko at California School of Fine Arts, San Francisco. At CSFA, befriends and learns lithography with Richard Diebenkorn (1947–49). Moves to New York; studies at Art Students League (1949–51). Looks closely at cubism and surrealism and the flat spatial perspective of de Chirico. Receives First Prize Medal for Painting, Corcoran Biennial, Washington, D.C. (1955); Guggenheim Fellowship (1956); and National Endowment for the Arts Fellowship (1974). Exhibits in Paris and Milan (1959) and has a solo exhibition at Musée des Beaux-Arts, Brussels, Belgium (1960). Represented in New York by Martha Jackson Gallery (1954–69) and, after Jackson's death, by David Anderson, her son (1970–80). Suffers from depression and creates densely packed, cubist polychrome paintings with apocalyptic imagery (1970s–80s). Receives Pollock-Krasner Foundation Grant for Painting (1988, 1992), Adolph and Esther Gottlieb Foundation Grant (1993, 1997), and Lee Krasner Fellowship for Lifetime Achievement in Art (1998). Elected a member of National Academy of Design, New York (1984). Dies in New York (2005). Work is in more than 150 public collections, including Smithsonian American Art Museum, Washington, D.C.; Albright-Knox Art Gallery, Buffalo, NY; Metropolitan Museum of Art, New York; Museum of Modern Art, New York; and Whitney Museum of American Art, New York. *Sole Witness*, a book of his poetry and painting, is published (2005).

> "There are no flat rules for getting at the workings of a painting, but I feel more than ever that the secrets lie in ambiguity; ambiguity that makes a complete final statement in the painting whole.…The canvas surface is flat and yet the space extends for miles. What a lie, what trickery—how beautiful is the very idea of painting." —Helen Frankenthaler

JACK JEFFERSON (1921–2000)

Born in Lead, SD (1921). Works as a shoveler at Homestake Gold Mine to save money for college (1939–40). Studies art at University of Iowa where Philip Guston and Fletcher Martin are on faculty (1940–42). Enlists in U.S. Marines (1942–45). Enrolls in California School of Fine Arts, San Francisco, where Clyfford Still becomes a close friend and mentor (1946–50) and where Frank Lobdell and James Weeks are students. Co-founds Metart Gallery, San Francisco; has first solo exhibition at Metart (1949–50). Receives traveling fellowship from San Francisco Art Association; travels through Pacific Northwest (1953–54). Shares studio space with Frank Lobdell in San Francisco's Audiffred Building (1954–59) after Ernest Briggs moves to New York. Begins two decades of teaching at CSFA (1959–79). Moves to waterfront studio on the Embarcadero; begins *Embarcadero* series (1962). M. H. de Young Memorial Museum, San Francisco, mounts solo exhibition of work from 1953 to 1962 (1962). Stops painting with oils due to severe allergies; begins mixed-media paintings on paper (1968). Included in Whitney Museum of American Art Biennial, New York (1975). Retires from teaching and continues painting on paper (1979–99). Begins exhibiting with Gallery Paule Anglim, San Francisco (1982–92). Dies in San Francisco (2000). Memorial exhibition organized at San Jose Museum of Art (2001). Hackett-Freedman Gallery, San Francisco, and Wiegand Gallery at Notre Dame de Namur University, Belmont, CA, mount a joint retrospective (2004).

JESS (1923–2004)

Born Burgess Collins in Long Beach, CA (1923). Studies at California Institute of Technology and is drafted into army to work on Manhattan Project (1939–47). Has a vision of the earth being destroyed by nuclear weapons in year 1975, which inspires a move to San Francisco to practice art full-time. (1948). Studies at University of California, Berkeley, and California School of Fine Arts, San Francisco, under Clyfford Still, Edward Corbett, Hassel Smith, Elmer Bischoff, David Park, and Clay Spohn; paints abstractions and semi-recognizable landscapes and portraits (1949–51). Begins lifelong relationship with poet Robert Duncan (1951); they collaborate on many future projects integrating poetry and illustration. First solo exhibition at Helvie Makela Gallery, San Francisco (1951). Receives Max Ernst's surrealist collage book *Une semaine de bonté*; begins producing *Paste-Ups*, works that combine fragments of magazine illustrations, comic strips, jigsaw puzzles, and other ephemera (1952–54). Co-founds, along with Duncan and painter Harry Jacobus, King Ubu Gallery, San Francisco (1953). Travels to Black Mountain College, Asheville, NC, where Duncan teaches (1955–56). Returns to San Francisco; illustrates poetry for White Rabbit Press (1956–57). Paints *Translations*, a series of twenty-six paintings based on enlarged reproductions of photographs, engravings, and literary texts (1959). *Dick Tracy Tricky Cad* series included in "Pop Art U.S.A." exhibition at Oakland Art Museum (1963). San Francisco Museum of Modern Art exhibits *Paste-Ups* (1968). Begins long association with Odyssia Gallery, New York (1971). Paints *Salvages*, works painted on abandoned canvases (1971–75). Museum of Modern Art, New York, exhibits *Translations* (1974). Begins exhibiting with Gallery Paule Anglim, San Francisco (1983). Albright–Knox Art Gallery, Buffalo, NY, organizes major traveling retrospective "Jess: A Grand Collage, 1951–1993," (1993), which travels to San Francisco Museum of Modern Art; Museum of Fine Arts, Boston; and Whitney Museum of American Art, New York. Dies in San Francisco (2004).

ALEX KATZ (1927–)

Born in New York City (1927). Studies at Cooper Union, New York (1946–49), and Skowhegan School of Painting and Sculpture, Skowhegan, ME (1949–50). Works from photographs in abstract expressionist manner (early 1950s). Receives first solo show at Roko Gallery, New York (1954). Starts painting minimal and brightly colored landscapes, still lifes, and figures and making collages (mid-1950s). Marries Ada, who becomes his primary model and muse for the majority of his career (1958). Starts painting portraiture of ordinary people, presaging later development of pop art (late 1950s). Teaches at New York Studio School, School of Visual Arts, both New York; Pratt Institute, Brooklyn, NY; and Yale University, New Haven, CT (1960s). Begins painting in more realistic, impersonal style and starts concentrating on printmaking and making freestanding figural cutouts in aluminum and wood (1960s). Receives first major retrospective at Whitney Museum of American Art, New York (1986), and a print retrospective at Brooklyn Museum of Art, NY (1988). Donates four hundred works to Colby College Museum of Art, Waterville, ME (1992). Alex Katz Visiting Chair in Painting endowed at Cooper Union, New York (1994). Solo exhibitions include Staatliche Kunsthalle, Baden-Baden (1995); Instituto Valenciano de Arte Moderno, Valencia (1996); P.S. 1 Contemporary Art Center, New York (1997–98); Saatchi Gallery, London (1998); Galleria Civica di Arte Contemporanea, Trento, Italy (1999); and Kunst und Ausstellungshalle der Bundesrepublik Deutschland, Bonn (2002). Begins association with PaceWildenstein Gallery, New York (2001). "Alex Katz Paints Ada, 1957–2005" opens at Jewish Museum, New York (2006–07). Currently lives and works in New York.

FRANZ KLINE (1910–1962)

Born in Wilkes-Barre, PA (1910). Attends Boston University and Boston Art Students League (1931–35). Moves to London and attends Heatherley's Art School (1935–38). Moves to New York (1939). Paints representational works in manner of John Sloan and William Glackens (late 1930s). Paints murals for bars in Brooklyn, NY, and Hoboken, NJ; wins $25 Prize awarded by Whitney Museum of American Art, New York, for a pen and ink drawing (1940). Receives S. J. Wallace Truman Prize at National Academy of Design, New York (1943). In the military reserves, meets Willem de Kooning (1943). After the war, becomes a regular at the Cedar Bar, along with de Kooning and Jackson Pollock (late 1940s–1950s). Becomes interested in Japanese art and starts painting calligraphic abstractions using black and white enamel paint (mid-1940s). Sees abstract brush drawings enlarged by a projector and begins painting in mature style (1949). Critic Clement Greenberg selects Kline to show in "Talent 1950" at Kootz Gallery, New York (1950). Receives first solo exhibition at Egan Gallery, New York, and is represented in

"Young Painters in U.S. and France" at Sidney Janis Gallery, New York (1950). After a decade exploring the limits of black and white, reintroduces color into his palette (mid-1950s). Included in Venice Biennale (1956; 1960 solo exhibition). Included in "Eight Americans" show at Janis Gallery with Josef Albers, Willem de Kooning, Arshile Gorky, Philip Guston, Robert Motherwell, Jackson Pollock, and Mark Rothko (1957). Dies in New York (1962). Posthumous solo exhibition organized by poet Frank O'Hara at Museum of Modern Art, New York, travels to six European capitals (1963–4). Retrospective traveling exhibition organized by Whitney Museum (1968–69). "The Vital Gesture: Franz Kline in Retrospect," organized by Cincinnati Art Museum, travels to San Francisco Museum of Modern Art and Philadelphia Museum of Fine Arts (1986).

LEE KRASNER (1908–1984)

Born in Brooklyn, NY (1908). Studies at Cooper Union, New York (1928); later transfers to National Academy of Design, New York (1930). Works for Works Progress Administration Federal Art Project in mural division; experiments with social realism and surrealist imagery of Giorgio de Chirico and Joan Miró (early 1930s). Studies with Hans Hofmann; begins painting abstract still lifes (1937–40). Marries Jackson Pollock (1945). Begins *Little Image* series (1946–47). Receives first solo exhibition at Betty Parsons Gallery (1951). Starts making collages (1953–55). Jackson Pollock dies (1956). Begins work on large gestural and emotional paintings in wake of Pollock's and her mother's death (1959–62). Creates series of collages that use and address works from her past, particularly charcoal drawings made while studying with Hofmann (mid–to late 1970s). *Eleven Ways to Use the Words to See* series exhibited at Pace Gallery, New York. Awarded the Chevalier de l'Ordre des Arts et des Lettres by the French Ministry of Culture (1982). Dies in New York (1984). Her will establishes the Pollock-Krasner Foundation, whose purpose is to provide financial assistance to visual artists of established ability (1985). Major solo exhibitions include "Lee Krasner: Large Paintings" at Whitney Museum of American Art, New York (1973–74); "Lee Krasner: A Retrospective," organized by The Museum of Fine Arts, Houston (1983–84); and "Lee Krasner," organized by Los Angeles County Museum of Art (1999–2001).

FRANK LOBDELL (1921–)

Born in Kansas City, MO (1921). Paints independently in Minneapolis (1940–42). Serves in U.S. Army in Europe (1942–46). Lives and paints in Sausalito, CA; paints and draws with George Stillman, Walter Kuhlman, James Budd Dixon, Richard Diebenkorn, and John Hultberg; group becomes known as the "Sausalito Six" (1946–49). Attends California School of Fine Arts, San Francisco, on G.I. Bill; studies with Clyfford Still and Ad Reinhardt (1947–50). Attends Academie de la Grande Chaumiere, Paris (1950–51). Included in "Pacific Coast Art" exhibition at the U.S. Pavilion at the Third Bienal of São Paulo, Brazil (1955). Teaches at San Francisco Art Institute, formerly CSFA (1957–65). Begins showing at Martha Jackson Gallery, New York (1958–74), and at Ferus Gallery, Los Angeles, curated by Walter Hopps (1957–63). Included in "Fifty California Artists" at Whitney Museum of American Art, New York (1962). Receives Nealie Sullivan Award from San Francisco Art Association (1960). Teaches at Stanford University; appointed chairman of the graduate program (1966–91). Exhibition of lithographs and painting at San Francisco Museum of Modern Art (1969). Included in Whitney Museum of American Art Annual Exhibition (1972). Receives medal for Distinguished Achievement in Painting from American Academy and Institute of Arts and Letters (1988) and an Academy Purchase Award (1992). Solo exhibitions at San Francisco Museum of Modern Art (1983); M. H. de Young Memorial Museum, San Francisco (1992); and Stanford University Art Museum (1993). Retrospective exhibition, "Frank Lobdell: The Art of Making and Meaning," travels from Fine Arts Museums of San Francisco to Portland Art Museum (2003–04). Currently lives and works in San Francisco.

CONRAD MARCA-RELLI (1913–2000)

Born in Boston, MA (1913). Moves to New York (1926). Attends Cooper Union, New York, and paints in spare time (1930). Joins Works Progress Administration Federal Art Project and meets Willem de Kooning, Franz Kline, and John Graham; work is informed by that of Giorgio de Chirico (1935–38). Receives first solo exhibition at Niveau Gallery, New York (1947). Travels in Europe; meets de Chirico and Henri Rousseau and exhibits in Italy (1948–49). Marries Anita Gibson and moves to East Hampton, Long Island, NY (1951). Travels to Italy and Mexico (1953). Paints large abstractions that feature layered and collaged canvas shapes—some are based on impressions of Mexican adobe bricks, others are biomorphic in nature (early 1950s). *Seated Figure* wins first prize

from Art Institute of Chicago (1954). Teaches at Yale University, New Haven, CT (1954–55, 1959–60), and participates in Venice Bienniale (1954–55). Teaches at University of California, Berkeley (1958). Starts including cutouts and industrial materials such as metal, rivets, and plastic in collages (1960s). Receives retrospective at Whitney Museum of American Art, New York (1967). Lives and exhibits predominately in Spain (1970–79). Returns frequently to New York (1980s–90s). Has solo exhibits at Marisa del Re Gallery, New York (1985–89). Moves to Parma, Italy (1996). Exhibition at Peggy Guggenheim Museum in Venice; receives honorary Italian citizenship (1999). Survey exhibition presented at Institut Mathildenhohe, Darmstadt, Germany; dies in Parma, Italy (2000).

FRED MITCHELL (1923–)

Born in Meridian, MS (1923). Studies at Carnegie Institute, Pittsburgh, where he meets and befriends painter Philip Pearlstein (1942–43). Drafted into U.S. Army (1943–45). Attends Cranbrook Academy, Bloomfield Hills, MI (1945–47). Wins first place in a painting competition sponsored by Pepsi Cola; award winners are included in a traveling exhibition organized by National Academy, New York; cash prize allows him to travel to Europe (1947). Works at Stanley William Hayter's Atelier 17, Paris, and attends Academy of Fine Arts, Rome; meets Afro (Basadella) and Philip Guston, both of whom influence Mitchell's work (1947–50). Moves to New York and is one of the first artists to establish a loft studio at Coenties Slip in downtown New York; subsequent residents include Robert Indiana, Agnes Martin, Jack Youngerman, and James Rosenquist; meets and befriends Ellsworth Kelly, who takes a studio near Mitchell's (1951). Co-founds Tanager Gallery, an artists' cooperative gallery, on East 9th Street, New York, where he has first solo exhibition (1952). Painting *Black White and Red* included in "Younger American Painters" exhibition at Guggenheim Museum, New York (1954). Exhibits with Stable Gallery, New York (1953–54). Teaches at Cranbrook Academy; New York University; Art Students League, New York; and The Fred Mitchell Workshop, New York (1950s–60s). Exhibits frequently at numerous galleries and museums, including Walker Art Center, Minneapolis; Whitney Museum of American Art, New York; and Museum of Modern Art, New York (1960s–90s). Currently lives and works in New York.

JOAN MITCHELL (1925–1992)

Born in Chicago, IL (1925). Attends Smith College but leaves after two years to concentrate on her art (1942–44). Spends summers in Mexico and becomes influenced by José Clemente Orozco (1943–46). Studies at Art Institute of Chicago (1944–49) and later at Columbia University, New York (1950). Travels to France on Ryerson Fellowship (1948–49). Establishes studio on St. Mark's Place, New York, and becomes exposed to New York school. Admires the work of Arshile Gorky, Franz Kline, and Willem de Kooning and socializes with them at the Cedar Bar. Abandons representation and starts painting abstractly; over time, work becomes known as painterly abstraction, with motifs inspired by landscape (1950–55). Receives New York solo exhibitions at Stable Gallery and frequently travels to France (1953–58). Meets Jean-Paul Riopelle (1955) and moves to Paris (1959). Moves to Vétheuil, France, to the house where Claude Monet had his studio; the setting informs much of her later work (1967). Shows extensively at galleries in New York and Paris for remainder of career (1967–92). Receives first retrospective at Whitney Museum of American Art, New York (1974). Retrospective exhibition organized by Herbert F. Johnson Museum at Cornell University, NY, travels to Corcoran Gallery of Art, Washington, D.C., and San Francisco Museum of Modern Art (1988). Dies in Paris (1992). Whitney Museum mounts national traveling retrospective (2002–04).

ROBERT MOTHERWELL (1915–1991)

Born in Aberdeen, WA (1915). Moves to California (1926). Receives scholarship to Otis Art Institute, Los Angeles. Studies at California School of Fine Arts, San Francisco (1932). Receives degree in philosophy at Stanford University (BA 1937) and attends Harvard University for graduate studies in philosophy (1937–38). First solo exhibition at Raymond Duncan Gallery, Paris (1939). Moves to New York to study art history at Columbia University under Meyer Schapiro; meets William Baziotes, Arshile Gorky, Mark Rothko, and Barnett Newman; becomes heavily involved with European surrealists (1940). Begins painting in surrealist manner; travels to Mexico with Chilean surrealist painter Roberto Matta (1941). Receives first solo exhibition at Peggy Guggenheim's gallery, Art of This Century, New York (1944). Starts editing *Documents of Modern Art* series (1944). Abandons surrealist imagery and starts working with abstract symbols (1946). First solo museum exhibition at San Francisco

Museum of Art (1946). Collaborates with William Baziotes, Mark Rothko, and, later, Barnett Newman in running the art school, The Subjects of the Artist, New York (1948–49). Begins *Elegy to the Spanish Republic*, a series of friezelike paintings that alternate vertical planes and oval shapes and that are a response to the horrors of war (1949). Teaches at Black Mountain College, Asheville, NC; Cy Twombly and Robert Rauschenberg are students (1950). Teaches at Hunter College, New York (1950–59). Marries Helen Frankenthaler (1958–71). Starts producing collages that incorporate material from his life (1960s). Works on *Open* series, a response to color field painting (1968–72). Retrospective at Museum of Modern Art, New York (1975). Elected to American Academy and Institute of Arts and Letters (1985). Awarded the Chevalier de L'Ordre des Arts et des Lettres, French Ministry of Culture, Paris (1988). Receives National Medal of Arts, Washington, D.C. (1990). Dies in Provincetown, MA (1991).

MANUEL NERI (1930–)

Born in Sanger, CA (1930). Attends San Francisco City College (1950–51); California College of Arts and Crafts, Oakland, where he meets Nathan Oliveira and studies ceramics with Peter Voulkos (1951); and University of California, Berkeley, where he stops studying engineering and turns to art (1951–52). Drafted into Korean War; attends studio classes at University of Seoul (1953–54). Returns to study at CCAC on G.I. Bill; studies with Nathan Oliveira and Richard Diebenkorn; begins assemblages, "junk" sculptures, and works with plaster; hears Allen Ginsberg read *Howl* at Six Gallery, San Francisco (1955–57). Transfers to California School of Fine Arts, San Francisco, primarily to study with Elmer Bischoff (1957–59). Makes life-size plaster figurative sculptures and *Stelae* series of painting/sculpture hybrids; becomes director of Six Gallery (1957). Teaches at CSFA (1957–59). Visits Mark Di Suvero in New York; stays for only three days (1958). Starts work on the *Window* series, abstract, gestural paintings that consist of large-color fields surrounding a centralized square (late 1950s–60s). Starts painting surfaces of sculptures; makes plaster heads and busts (1959). Marries Joan Brown (1962–66). Teaches at UC Berkeley (1963–64). Converts former Congregational church in Benicia, CA, into a studio (1964). Stops working on figurative sculpture (1965–mid-1970s). Starts lecturing at University of California, Davis (1965); becomes a professor at UC Davis (1976). Begins working with model Mary Julia Klimenko (1970). Starts working on a series of drawings that feature a monumental figure placed in the center of a painted sheet (1976). Oakland Museum of California organizes retrospective (1976). Receives Academy Institute Award in Art, American Academy and Institute of Arts and Letters (1982). Begins sculpting in Carrara marble (mid-1980s). Museum retrospectives held at San Francisco Museum of Modern Art (1989) and Corcoran Gallery of Art, Washington, D.C. (1997). Receives Lifetime Achievement Award from International Sculpture Center (2006). Currently lives and works in Benicia, CA, and Carrara, Italy.

LOUISE NEVELSON (1899–1988)

Born Louise Berliawsky in Kiev, Russia (1899). Family moves to United States and settles in Rockland, ME, where father runs a lumber mill, inspiring an early respect and familiarity for the material (1905). Marries Charles Nevelson and moves to New York (1920); studies at Art Students League with Hilla Rebay (1928–30); becomes familiar with work of Marcel Duchamp and Picasso. Separates from Nevelson; travels to Europe and briefly studies with Hans Hofmann in Munich (1931). Returns to New York; works as assistant to Diego Rivera on Works Progress Administration Federal Art Project murals (1932–33). Starts making cubist-inspired sculptures (early 1930s). Receives first solo exhibition at Nierendorf Gallery, New York; divorces Nevelson (1941). Begins *Farm* assemblages, which use wood and found objects (1943). Works at Sculpture Center, New York; experiments with printmaking at Stanley William Hayter's Atelier 17, New York (1949–50). Executes marble and terra-cotta *Game* figures (1949–50). Whitney Museum of American Art, New York, acquires *Black Majesty* (1956). Starts making black shadow boxes and relief walls (1957). Museum of Modern Art, New York, purchases *Sky Cathedral* (1958). "Sky Columns Presence" solo exhibition at Martha Jackson Gallery, New York; included in "Sixteen Americans" exhibition at Museum of Modern Art (1959). Begins making all white and gold walls (1959). Begins long association with Pace Gallery, Boston, later PaceWildenstein, New York (1960). Begins exhibiting at Pace Gallery, Boston (1961). Represents United States at Venice Biennale (1962, 1976). Receives major museum retrospectives at Whitney Museum (1967, 1980) and Walker Art Center, Minneapolis (1973). Starts producing aluminum and monumental Cor-ten steel structures (mid-1960s). Elected a member of American Academy and Institute of Arts and Letters (1979). Dies in New York (1988).

NATHAN OLIVEIRA (1928–)

Born in Oakland, CA (1928). Studies at California College of Arts and Crafts, Oakland, attends summer session taught by Max Beckmann (BFA 1951, MFA 1952). Receives temporary draft deferment to teach printmaking at CCAC (1952). Begins two-year service in U.S. Army (1953). Teaches at CCAC and California School of Fine Arts, San Francisco (1955). Hired by Gurdon Woods to head graphic arts department at CSFA (1956). Receives Guggenheim Fellowship for Printmaking; travels in Europe (1958). First solo exhibitions at Eric Locke Gallery, San Francisco (1957), and Alan Gallery, New York (1958). Joins Paul Kantor Gallery, Los Angeles (1958). Resigns from CSFA and begins teaching graduate painting at CCAC (1960). Teaches studio art at Stanford University (1964–95). Shows works on paper in solo exhibition at San Francisco Museum of Art (1969). Shows at Charles Campbell Gallery, San Francisco (1971–79); moves to John Berggruen Gallery, San Francisco (1980). Receives Academy Institute Award in Art, American Academy and Institute of Arts and Letters (1984); Ann O'Day Maples Professor in the Arts Emeritus, Stanford University (1992); and Honorary Doctorate of Fine Arts, Honoris Causa, San Francisco Art Institute (1996). San Francisco Museum of Modern Art organizes traveling exhibition "Nathan Oliveira: A Survey Exhibition 1957–1983" (1984). Elected a Fellow at American Academy of Arts and Sciences (1994). San Jose Museum of Art organizes major traveling retrospective (2002–03). Currently lives and works in Stanford, CA.

> "Manuel would put on plaster real fast, take a hatchet real fast, cut that arm off, throw it away and twenty minutes later he's got a new arm on there. And…with painting you just didn't bother to mix anything.… And this tremendous spontaneity added to the energy that was happening." —Joan Brown

DAVID PARK (1911–1960)

Born in Boston (1911). Studies at Otis Art Institute, Los Angeles (1928–29), then attends art classes at University of California, Berkeley (1929) while working as a studio assistant to San Francisco sculptor Ralph Stackpole. Marries Lydia Newell (1930). Joins work on Works Progress Administration Federal Art Project public fresco and tapestry projects. Paints in an early modernist style; work is greatly informed by cubism and later surrealism (1930s–early 1940s). Receives first solo exhibition at San Francisco Museum of Modern Art (1935). Moves to Boston with family to teach until 1941, then returns to Berkeley and works at General Cable Company (1941–45). Teaches at California School of Fine Arts, San Francisco, with Elmer Bischoff and Hassel Smith, under director Douglas MacAgy (1945–52). Has a solo show at California Palace of the Legion of Honor, San Francisco (1946). Paints non-objectively for the next several years; exhibits abstract works at San Francisco Museum of Modern Art (1948). Destroys all of his abstract painting (1949) and returns to figuration (1949–50). *Kids on Bikes* wins first place award at M. H. de Young Memorial Museum exhibition, San Francisco (1951). Resigns from CSFA to protest Hassel Smith's dismissal (1952). Solo exhibitions at King Ubu Gallery, San Francisco, and Paul Kantor Gallery, Los Angeles (1950–54). Works from models in drawing sessions with Bischoff, Richard Diebenkorn, and, periodically, William Theophilus Brown, Nathan Oliveira, James Weeks, and Paul Wonner (mid-1950s). Teaches at UC Berkeley (1955–60). Retrospective exhibition at de Young museum (1959). Due to terminal cancer, ceases oil painting and turns to felt-tip markers and gouache. Completes approximately one hundred gouaches in ten weeks (1960). Dies in Berkeley (1960). "David Park 1911–1960 Retrospective Exhibition" travels to Institute of Contemporary Art, Boston, MA; Corcoran Gallery of Art, Washington D.C.; Oakland Art Museum; and Staempfli Gallery, New York (1962). Whitney Museum of American Art, New York, and Oakland Museum of California organize a major traveling retrospective (1989).

ROLAND PETERSEN (1926–)

Born in Endelave, Denmark (1926). Attends University of California, Berkeley (BA 1949, MA 1950). Studies with Hans Hofmann in Provincetown, MA (1950–51). Teaches at Washington State University, Pullman (1952–56). Receives solo exhibitions at Oakland Art Museum (1954) and California Palace of the Legion of Honor, San Francisco (1961). Moves to Davis, CA, to teach at University of California, Davis; recruits Wayne Thiebaud, Manuel Neri, and Robert Arneson to the faculty (1956–91). Begins work on *Picnic* series of paintings (1960). Has solo show at Staempfli Gallery, New York (1963; 1965; 1967). Solo exhibition at Crocker Art Museum, Sacramento (1965). Develops severe allergies to oil paints and starts working with acrylics (early 1970s). Attends Stanley William Hayter's Atelier 17, Paris (1970–71). Traveling retrospective of color prints organized by Museum of Art, Pullman, Washington (1976). Painting retrospective held at Memorial Union Art Gallery, Davis, CA (1978). Endelave Museum, Endelave, Denmark, organizes traveling exhibition (1998). Begins exhibiting with Hackett-Freedman Gallery, San Francisco (2002). Currently lives and works in San Francisco. Work included in collections of San Francisco Museum of Modern Art; Hirshhorn Museum and Sculpture Garden, Washington, D.C.; Museum of Modern Art, New York; Whitney Museum of American Art, New York; Oakland Museum of California; Fine Arts Museums of San Francisco; and Philadelphia Museum of Art, among others.

AD REINHARDT (1913–1967)

Born in Buffalo, NY (1913). Studies art history at Columbia University, New York, under the influential art historian Meyer Schapiro (BA 1935). Attends National Academy of Design (1936) and American Artists School run by abstract painters Carl Holty and Francis Criss (1936–37). Works for Works Progress Administration Federal Art Project in the easel division; paints collage-based works with solid, cubist-based geometric forms (1936–41). Organic, gestural paintings replace earlier forms (1940s). First solo exhibition at Columbia Teachers College (1943). Serves in U.S. Navy (1944–45). Joins American Abstract Artists (1937–47). Becomes affiliated with Artists' Union and American Artists' Congress, through which he meets Stuart Davis, who becomes a great inspiration. Begins lifetime association with Betty Parsons Gallery, New York (1946–67). Included in "The Ideographic Picture" exhibition organized by Barnett Newman at Betty Parsons Gallery; show also includes Theodoros Stamos and Hans Hofmann (1947). Begins influential teaching career at Brooklyn College, NY, as a teacher of art history (1947–67). Shows renewed interest in cubist structure and starts simplifying pictures and using monochromatic palettes (1948). Lectures at California School of Fine Arts, San Francisco; meets Edward Corbett who becomes an important influence (1950). Teaches with Josef Albers at Yale University, New Haven, CT (1952–53). Experience with Albers inspires a return to geometry; begins to produce works dominated by a grid and a single color—first red, then blue, then black; breaks away from abstract expressionist modes of expression, becoming a pioneer of Hard-edge painting, a term used to describe contemporary geometric abstract painting (1950s). Begins series of all-black paintings, which he calls the "ultimates." This series cements Reinhardt's role as a major precursor to minimalism and preoccupies him for the remainder of his career (1954–67). Jewish Museum, New York, mounts major solo exhibition (1966). Dies in New York (1967). Posthumous solo exhibitions include the "Black Paintings 1951–67," Marlborough Gallery (1970); Solomon R. Guggenheim Museum (1980); and Museum of Modern Art (1991), all New York.

LARRY RIVERS (1923–2002)

Born in New York City (1923). Begins career as a jazz musician and changes last name from Grossberg to Rivers (1940). Serves in U.S. Army Air Corps during World War II (1942–43). Plays saxophone in jazz bands in New York and studies at Juilliard School of Music, New York (1944–45). Starts painting abstract works at the encouragement of Nell Blaine and Jane Freilicher (1945). Studies with Hans Hofmann in New York and Provincetown, MA (1947–48), and with William Baziotes at New York University (1948). Sees Pierre Bonnard retrospective at Museum of Modern Art, New York, and begins to paint figurative subject matter taken from family life and familiar surroundings (1948). Receives first solo exhibition at Jane Street Gallery (1949). Obtains art education degree from NYU (BA 1951). Starts to develop technique that merges painting and drawing. Travels to Paris and visits the Louvre; begins works based on great history paintings (early 1950s). Joins Tibor de Nagy Gallery, New York (1951–62). Museum of Modern Art acquires *Washington Crossing the Delaware* (1955). Included in São Paulo Bienal, Brazil (1956). Begins reinterpreting and appropriating imagery from old master and nineteenth-century

paintings (1960s). Publishes poetry in *Locus Solus*, vols. 3–4 (1962). Starts working with mass media images and found objects (1960s). Rose Art Museum, Brandeis University, Boston, mounts first traveling retrospective, which includes painting *The History of the Russian Revolution: From Marx to Mayakovsky* (1965). Begins to use spray cans, air brush, and video tapes (1969–70). Art Institute of Chicago mounts major solo exhibition; begins relationship with Marlborough Gallery, New York (1970–99). Begins *Golden Oldies* series, revising works done in the fifties and sixties (1978). Receives first European traveling retrospective in Germany (1980–81). Dies in Southampton, Long Island, NY (2002). Corcoran Gallery, Washington, D.C., mounts major posthumous retrospective (2002).

> "*How is a great work of art recognized?*
>
> A great work of art is always affirmative and never merely suggestive. It is always implicit and not explicit. The great art is always ceremonial. The great art is terrifying, sometimes monstrous and repellent, but always beautiful. When the gods speak, the figure is stupendous and frightful." —John Graham

MARK ROTHKO (1903–1970)

Born Marcus Rothkowitz in Dvinsk, Russia (1903). Family immigrates to Portland, OR (1913). Attends Yale University, New Haven, CT (1921–23). Moves to New York and studies at Art Students League under Max Weber (1925). Befriends Milton Avery, whose work is a seminal influence (late 1920s). Teaches at Center Academy, Brooklyn, NY (1929–52). First solo exhibitions at Portland Art Museum, Portland, OR, and Contemporary Arts Gallery, New York (1933). Starts painting pictures informed by Avery and Matisse—simplified compositions with flat areas of color (early 1930s). Co-founds The Ten, a group of New York expressionist painters (1935). Works in mural division of Works Progress Administration Federal Art Project (1936–37). Works in surrealist manner using calligraphic and biomorphic imagery; introduces horizontal bands of color (1942–47). Begins painting pure abstractions with soft-edged areas of color; first color field paintings (1947–49). Meets Clyfford Still in Berkeley, CA (1943). Invited to teach at California School of Fine Arts, San Francisco, at Still's urging (summers, 1947; 1949). Establishes The Subjects of the Artist School in New York with William Baziotes, Robert Motherwell, and Barnett Newman (1948–49). Works become more somber and darker (late 1950s). Represents United States at Venice Biennale (1960). Solo exhibition at Museum of Modern Art, New York (1961). Starts layering colors to create velvety surface; shape and ground disappear (1960s). Works on paintings for Rothko Chapel, Houston (1964–67). Commits suicide in New York (1970). Posthumous retrospectives include Nationalgalerie, Berlin (1971); Solomon R. Guggenheim Museum, New York (1978); San Francisco Museum of Modern Art (1983); Walker Art Center, Minneapolis (1984); Tate Gallery, London (1986); and National Gallery of Art, Washington, D.C. (1998).

JUDITH ROTHSCHILD (1921–1993)

Born in New York City (1921). Attends Wellesley College, MA (BA 1943). Studies at Art Students League, New York, with Reginald Marsh and later at Hans Hofmann's school in New York; publishes "Abstract versus Non-Objective Art" in *12th Street* (1934–44). Works at Stanley William Hayter's studio Atelier 17, New York; joins Jane Street (figurative) artists' cooperative, which includes Leland Bell, Nell Blaine, and Jane Freilicher; meets mentor Karl Knaths (1945). Joins American Abstract Artists (1946). Has first solo exhibition at Rose Fried Gallery, New York. Marries writer Anton Myrer and moves to Monterey, CA (1947–48). Starts spending summers in Provincetown, MA, and rest of the year in California (1949). Stops exhibiting with American Abstract Artists due to increasing

doubts about abstraction (1953). Paints abstracted seascapes in California and translates Cézanne's letters (1955). Returns to New York to live and travels to Europe (1956–58). Views Matisse retrospective at Grand Palais, Paris, stops easel painting, and starts creating large-scale relief paintings, which combine figurative and abstract elements; divorces Myrer (1970). Rejoins American Abstract Artists after reconsidering twenty-year break with pure abstraction (1973). Receives traveling retrospective at Pennsylvania Academy of the Fine Arts, Philadelphia (1987–88), and solo exhibition at Tretyakov Museum, Moscow (1991). Dies in New York (1993); Rothschild's will establishes The Judith Rothschild Foundation, whose mission is to promote the work of deceased American artists whose work merits increased recognition. Posthumous exhibitions include Metropolitan Museum of Art retrospective "Judith Rothschild: An Artist's Search," which travels to Phillips Collection, Washington, D.C., and San Francisco Museum of Modern Art (1998); State Russian Museum, St. Petersburg (2002); and Von Der Heydt–Museum, Wuppertal, Germany (2003).

JOHN SACCARO (1913–1981)

Born in San Francisco (1913). Writes plays and short stories (1932–53). Works in Easel Painters and Mural Sections of the Works Progress Administration Federal Art Project, specifically on the design and painting of San Francisco Federal Building murals, a mosaic for Golden Gate International Exposition, and the murals and facade of Aquatic Park Building (1939–41). First solo exhibition at age 25 at San Francisco Museum of Art (1939). Works as a U.S. Army camouflager in France during World War II (c. 1942–46). Solo exhibitions at M. H. de Young Memorial Museum, San Francisco (1946, 1956, 1960). Attends California School of Fine Arts, San Francisco, and studies under Elmer Bischoff, David Park, and James Budd Dixon (1951–54). Develops the term "sensorism" to describe painting technique of using slashing, gestural brushwork to create densely layered abstract patterns and colors that are meant to provoke visceral sensations in the viewer (early 1950s). Included in "Pacific Coast Art" exhibition at the São Paulo Bienal, Brazil (1955). Exhibits at Oakland Art Museum (1958). Second solo exhibition at San Francisco Museum of Art (1959–60). Exhibits at Bolles Gallery, New York (1962). Teaches at University of California, Los Angeles (1963–64). Begins painting smaller works with simpler, natural forms (1960s–70s). Dies in San Francisco (1981). Work is in many public collections, including Oakland Museum of California; San Francisco Museum of Modern Art; Pasadena Art Museum; de Young Museum; Crocker Art Museum, Sacramento; and Laguna Art Museum, Laguna Beach, CA.

"Every intelligent painter carries the whole culture of modern painting in his head. It is his real subject, of which anything he paints is both an homage and a critique." —Robert Motherwell

JON SCHUELER (1916–1992)

Born in Milwaukee, WI (1916). Attends University of Wisconsin, Madison (BA Economics, 1938; MA English Literature, 1940). Serves in U.S. Air Force during World War II (c. 1941–44). Moves to Los Angeles and starts painting (1945). Moves to San Francisco to teach English literature at University of San Francisco (1947–48). Attends California School of Fine Arts; studies under Clyfford Still, who becomes an important mentor and influence; also studies with Richard Diebenkorn and Mark Rothko (1948–51). First solo exhibition at Metart Galleries, San Francisco (1950). Follows Still to New York and stays close to Still, Edward Dugmore, and Ernest Briggs (1951). Begins *Sky* series, entirely black abstract works with flashes of color that recall nighttime bombing missions during World War II (early 1950s). Palette lightens, begins incorporating more color into work, and softens brushwork, reflecting influence of J. M.W. Turner (mid-1950s). Exhibits in New York with Stable Gallery (1954, 1961, 1963) and Leo Castelli (1957, 1959). Travels and establishes studio in Mallaig, Scotland, and Paris (1957–59). Returns to New York (1959). Teaches at Yale University, New Haven, CT (1960–62); Maryland Institute,

College of Art, Baltimore (1963–67); University of Pennsylvania, Philadelphia (1965); and University of Illinois, Urbana (1968–69). Moves to Mallaig (1970–75). Solo exhibitions at Edinburgh College of Art, Edinburgh, and Whitney Museum of American Art, New York (1975). Lives in New York and Mallaig (1975–92). Dies in New York (1992). *The Sound of Sleat: A Painter's Life*, a memoir, is published posthumously (1999). Posthumous solo exhibitions include City Art Centre, Edinburgh, accompanied by a major monograph by Gerald Nordland and Richard Ingleby (2002); Scottish National Gallery of Modern Art, Edinburgh (2005–06); and Telfair Museum of Art, Savannah, GA (2006).

CLAY SPOHN (1898–1977)

Born in San Francisco (1898). Attends California College of Arts and Crafts, Oakland (1910–16). Studies at California School of Fine Arts, San Francisco (1914, 1920–21). Attends University of California, Berkeley (1919–22). Studies at Art Students League, New York, under Guy Pène duBois, George Luks, and Boardman Robinson; befriends Alexander Calder (1922–24). Travels in Europe (1926); studies at Académie Moderne, Paris, under Othon Friesz; meets Marcel Duchamp and Stanley William Hayter; inspires Calder to work with wire; starts making sculpture from found materials (1926–27). Returns to San Francisco (1927). First solo exhibition at San Francisco Art League (1931). Works for Works Progress Administration Federal Arts Project on murals at Montebello, CA, post office (1938) and Los Gatos Union High School (1939). Works on decorations for first San Francisco open air show; creates *Fantastic War Machines and Guerragraphs*, a series of colorful, quasi-surreal gouaches (1941–42). Exhibits *Wake Up and Live* at San Francisco Museum of Art, a kinetic sculpture of a painted fly and a flyswatter (1941). Works as a technical illustrator in U.S. Navy (1942–44). Solo exhibition at San Francisco Museum of Art (1942). Teaches at CSFA alongside Clyfford Still and Mark Rothko; encourages Hassel Smith, Richard Diebenkorn, and Elmer Bischoff to explore abstract expressionism (1945–50). Exhibits at Rotunda Gallery, City of Paris department store, San Francisco (1946). Exhibits at Stables Gallery, Taos, NM (1947). Creates *Museum of Unknown and Little-Known Objects*, an installation of forty-two assemblages made from found objects at CSFA; establishes role as a major precursor to Funk art (1949). Lives in New York (1950–51). Moves to Taos and spends time with Edward Corbett and Richard Diebenkorn, together they become known as Taos Moderns group; divides time between New York and Taos (1951–71). Teaches at Mount Holyoke College, South Hadley, MA (1958). Teaches at School of Visual Arts, New York (1964–69). Solo exhibition at Oakland Museum (1974). Dies in New York (1977).

THEODOROS STAMOS (1922–1997)

Born in New York City (1922). Receives a scholarship to study sculpture at American Artist's School (1936–39). Abandons sculpture and starts painting on canvas; is self-taught in the medium (1939). Opens a framing shop near Union Square, New York; customers include Arshile Gorky and Fernand Léger (1941). Receives first solo exhibition at Betty Parsons Gallery; meets Adolph Gottlieb and Barnett Newman (1943). Meets Mark Rothko and Mark Tobey (1947). Begins using bands of dark or black color in paintings, which are mythological in nature and feature natural and calligraphic forms (mid- to late 1940s). Travels to Europe and meets Brancusi, Giacometti, and Picasso (1948). Works on *Teahouse* paintings, which use flatter space and simpler forms (1949–52). Teaches at Black Mountain College, Asheville, NC, where he meets Clement Greenberg and tutors Kenneth Noland (1950) and at Hartley Settlement House (1950–54). Youngest member of "The Irascibles," a group of first-generation New York abstract expressionists. Delivers "Why Nature in Art?" lecture at Phillips Collection, Washington D.C., and discusses importance of Oriental art (1954). Begins *Sun-Box* series, large-scale paintings that feature geometric shapes and monochrome backgrounds (1962–70). Teaches at Brandeis University, Boston, where he meets frequently with Rothko (1967–68). Begins two-decade-long *Infinity Field* series in which nature is primary subject (1971–90). Establishes home on Greek island of Lefkada and divides his time between Greece and New York (1970s–90s). Dies in Ioannina, Greece; National Gallery and Alexandros Soutzos Museum, Athens, mounts posthumous retrospective same year (1997). Work is included in many major museum collections, including Art Institute of Chicago; Detroit Institute of Arts; Metropolitan Museum of Art, New York; Museum of Modern Art, New York; and Whitney Museum of American Art, New York.

RICHARD STANKIEWICZ (1922–1983)

Born in Philadelphia (1922). Receives first art training at Class Technical High School, Detroit (1936–40). Serves in U.S. Navy during World War II (1941–48). Moves to New York and attends Hans Hofmann School; works as a freelance mechanical draftsman for patent attorneys (1948–50). Attends Academie de la Grande Chaumiere, Paris, and studies under Fernand Léger and Ossip Zadkine (1950–51). Returns to New York and starts making "junk" sculptures using scrap metal and discarded mechanical equipment; the pieces combine formal integrity with a sense of humor and are both figurative and abstract. Work prefigures sculptures of Jean Tinguely and later work by Claes Oldenburg and Robert Rauschenberg (early 1950s). Co-founds cooperative Hansa Gallery, New York, named in honor of Hans Hofmann and founded by a group of former students. (1952). First solo exhibition at Hansa Gallery (1953). Begins representation with Stable Gallery, New York; included in Whitney Museum of American Art Annual exhibition, New York; Carnegie International Exposition, Pittsburgh; and Venice Biennale (1958). Included in "The Art of Assemblage," Museum of Modern Art, New York, and "Le Nouveau Realism a Paris et a New York," Galerie Rive Droite, Paris (1961). Moves to Huntington, MA (1962). Begins association with Zabriskie Gallery, New York (1972). Receives first traveling retrospective mounted by University Art Gallery, Albany, NY (1979). Dies in Huntington, MA (1983). Posthumous traveling retrospective at Addison Gallery of American Art, Andover, MA (2003). Works included in many public collections, including Addison Gallery of American Art; Courtauld Institute of Art, London; Hirshhorn Museum and Sculpture Garden, Washington, D.C.; Smithsonian American Art Museum, Washington D.C.; and Walker Art Center, Minneapolis.

CLYFFORD STILL (1904–1980)

Born in Grandin, ND (1904). Attends Spokane University, WA (BA 1933) and Washington State College, Pullman (MA 1935). Teaches at Washington State College (1933–41). Starts moving away from representation and toward abstraction; experiments with surrealism (1938–42). Works in defense factories during World War II (1941–43). Moves to New York and has solo exhibition at Peggy Guggenheim's gallery Art of This Century (1945–46). Enters mature period, making large paintings with ragged shapes that fill canvas with a dominant color and are accented by contrasting hues at the edge of the composition (1944). Returns to San Francisco to teach at California School of Fine Arts; his tenure is extremely influential and has a profound impact on students and fellow teachers, who include Jack Jefferson, Frank Lobdell, John Saccaro, Ernest Briggs, and Edward Dugmore (1945–50). First solo exhibition at San Francisco Museum of Art; meets Mark Rothko (1946). Has solo exhibition at California Palace of the Legion of Honor, San Francisco (1947). Exhibits at Betty Parsons Gallery, New York (1947, 1950, 1951). Moves back to New York; Saccaro, Briggs, and Dugmore follow (1950). Severs all ties with commercial art galleries and stops exhibiting (early 1950s). Albright-Knox Art Gallery, Buffalo, NY, mounts rare retrospective with Still's permission (1959); later donates thirty-one paintings to museum (1964). Moves to a farm in Maryland, near Westminster, and works in seclusion for remainder of career (1961). Receives Award of Merit for Painting, American Academy and Institute of Arts and Letters (1972). Bequeaths twenty-eight works of art to San Francisco Museum of Modern Art (1975). Metropolitan Museum of Art, New York, mounts major retrospective (1979). Dies in Baltimore, MD (1980); his will stipulates that 750 oil paintings and 13,000 works on paper never be "sold, given, or exchanged" and can be installed only in a museum built to his specifications. "Clyfford Still, 1904–1980: The Buffalo and San Francisco Collections," international traveling exhibition, is organized by Albright-Knox Art Gallery (1992–93). City of Denver is chosen to receive artworks in the estate (2004); Clyfford Still Museum scheduled to open in 2009.

WAYNE THIEBAUD (1920–)

Born in Mesa, AZ (1920). Works at Walt Disney Studios while attending high school (1936–37). Studies commercial art at Frank Wiggins Trade School, Los Angeles; works in Long Beach, CA, as a cartoonist (1938–41). Serves in U.S. Army Air Force (1942–45). Works as illustrator, designer, cartoonist, Long Beach, CA (1946–49). Decides to become a painter, attends San Jose State College (1949–50); California State College, Sacramento (BA 1951, MA 1953). Teaches at Sacramento Junior College; paints in a variety of styles (1951–60). Has first solo exhibition at E. B. Crocker Art Gallery, Sacramento (1951). Visits New York and meets Elaine and William de Kooning, Franz Kline, and Barnett Newman (1926); paints in abstract expressionist manner for several years (1956–59). Serves as a guest instructor in printmaking, California School of Fine Arts, substituting for Nathan Oliveira (summer,

1958). Begins painting still lifes of pies, cakes, and other mundane objects (1960). Starts teaching at University of California, Davis (1960–90; Professor Emeritus). Travels to New York; meets dealer Allan Stone (1961). Solo exhibition at Allan Stone Gallery; solo exhibition at M. H. de Young Memorial Museum, San Francisco; included in "New Realists" exhibition at Sidney Janis Gallery, New York (1962). Begins working with Crown Point Press, Oakland, later in San Francisco (1963). Starts painting more landscapes, first rural then urban scenes (1966). Represents United States at São Paulo Bienal, Brazil (1967). Begins weekly drawing sessions in San Francisco; group includes Mark Adams, Theophilus Brown, Gordon Cook, and Beth Van Hoesen (1976). San Francisco Museum of Modern Art organizes major traveling retrospective (1985). Paints brightly colored, planar landscapes of Sacramento delta (mid-1990s). Receives National Medal of Arts, Presidential Award (1994); Fine Arts Museums of San Francisco organizes major painting retrospective, which travels to Phillips Collection, Washington, D.C., and Whitney Museum of American Art, New York (2000). Currently lives and works in San Francisco.

JACK TWORKOV (1900–1982)

Born in Biala, Poland (1900). Immigrates with family to New York (1913). Attends Columbia University and studies English and art history (1920–23). Sees Cézanne's paintings at Brooklyn Museum exhibit (1921). Transfers to National Academy of Design, New York (1923–25). Begins spending summers in Provincetown, MA, and studies under Karl Knaths; becomes familiar with work of Kandinsky, Klee, and Miró (1923). Takes classes at Art Student's League, New York, and studies with Boardman Robinson and Guy Pène duBois (1925). Works for Works Progress Administration Federal Art Project and meets Willem de Kooning (1935–41). Serves in World War II as a tool designer (1942–45). Paints still lifes; turns to abstraction (1945–47). Exhibits with Egan Gallery, New York (1947). Maintains adjoining studio with de Kooning; paints regularly with Knaths and Franz Kline (1948–53). Teaches at Black Mountain College, Asheville, NC (1949). Founding member of The Club, the primary forum for abstract expressionist art in New York (1949). Starts developing a balance between deliberation and spontaneity in his paintings (1950s). Teaches art at Yale University, New Haven, CT; later becomes chairman of the art department (1950–69). Establishes permanent studio in Provincetown; included in Museum of Modern Art traveling exhibition "The New American Painting" (1958). Abandons abstract expressionist mode in favor of a more geometric, linear structure (mid-1960s). Receives Corcoran Gold Medal at 28th Biennial Exhibit of American Painting (1963). Receives solo exhibitions at Whitney Museum of American Art, New York, and San Francisco Museum of Art (1964). Receives honorary doctorates from Maryland Institute of Art, Baltimore (1971); Columbia University, New York (1972); and Rhode Island School of Design, Providence (1979). Elected to American Academy and Institute of Arts and Letters, New York (1981). Retrospective held at Solomon R. Guggenheim Museum, New York (1982). Dies in Provincetown, MA (1982).

CHARMION VON WIEGAND (1896–1983)

Born in Chicago, IL (1896). Lives with family in Arizona and San Francisco; memories of San Francisco's Chinatown foster lifelong interest in Asian culture (1908–11). Attends Barnard College, New York, and studies journalism and art history (1915). Marries and moves to Darien, CT (c. 1915). Realizes she wants to become a painter after undergoing intense psychoanalysis; starts painting casual landscapes (1926). Divorces husband and travels to Moscow where she becomes a correspondent for Hearst Newspapers (1929). Returns to New York and marries Joseph Freeman, editor and co-founder of *New Masses* (1932). Continues to write art criticism and reviews for *ARTnews*, *Arts Magazine*, and *New Masses*, among others (1930s). Meets Piet Mondrian through Carl Holty; stops painting entirely for a year and half while undergoing intense study of Neo-plasticism, a term coined by Mondrian to describe the reduction of all natural elements to areas of primary color contained by a grid of black and white (1941). Joins American Abstract Artists at urging of Holty (1941; as president 1951–53). First solo exhibition at Rose Fried Gallery, New York. Begins painting full-time after death of Mondrian; exploring the spiritual aspects of Mondrian's Neo-plastic theory (1944). Starts making collages in the manner of Kurt Schwitters (1946). Becomes involved with Theosophy, which emphasizes Buddhist theories of pantheistic evolution and reincarnation, and incorporates metaphysical imagery into paintings; work becomes overtly mystical, and her break with Neo-plasticism is complete (1960s). Elected to American Academy and Institute of Arts and Letters (1980). Receives first retrospective at Bass Museum of Art, Miami Beach (1982). Dies in New York (1983). Work

is represented in numerous museum collections, including Solomon R. Guggenheim Museum, New York; Hirshhorn Museum and Sculpture Garden, Washington, D.C.; Metropolitan Museum of Art, New York; Museum of Modern Art, New York; and Whitney Museum of American Art, New York.

ANDY WARHOL (1928–1987)

Born Andrew Warhola in Pittsburgh, PA (1928). Studies design at Carnegie Institute of Technology (now Carnegie Mellon University), Pittsburgh (BFA 1949). Moves to New York and works as a commercial artist and illustrator (1949–63). Makes outline drawings, many commissioned by fashion houses, that are whimsical in nature and use a delicate blotted line that makes originals appear printed (1950s). First solo exhibition of drawings at Hugo Gallery, New York (1952). Wins Art Directors' Club Medal for shoe advertisements (1957). Begins to make paintings based on mass-produced imagery such as advertisements and comic strips, representing some of the earliest examples of pop art (1960). Starts using screen prints for mechanical production of enlarged photographic images of popular iconography; images screened onto background of flat, interlocking or single areas of color; establishes his studio The Factory; uses assistants to reproduce images repeatedly, the effect is to obviate any meaning (1962). Exhibits thirty-two of his *Campbell Soup Can* images at Ferus Gallery, Los Angeles (1962). Warhol Films Factory produces *Sleep* (1963). Installation of supermarket carton sculptures at Stable Gallery, New York (1964). Announces intention to retire from painting in order to make experimental films (1963); makes *Chelsea Girls* (1966), *Lonesome Cowboys* (1968), and *Trash* (1970). Shot in the chest by Valerie Solanas, founder and sole member of SCUM (Society for Cutting Up Men); attack is nearly fatal (1968). Founds *Interview* magazine (1969). Works primarily on portraits printed from Polaroid photographs, including Jackie Kennedy, Mao Tse-tung, and Marilyn Monroe (1970s). Produces a group of collaborative paintings with Francesco Clemente and Jean-Michel Basquiat; returns to painting by hand (1980s). Dies in New York (1987); his will establishes Andy Warhol Foundation for the Visual Arts, which supports cultural organizations that support the visual arts. Museum of Modern Art, New York, mounts major retrospective (1989). Andy Warhol Museum, Pittsburgh, opens (1994).

PAUL WONNER (1920–)

Born in Tucson, AZ (1920). Moves to San Francisco Bay Area (1937). Attends California College of Arts and Crafts, Oakland (1941). Drafted into U.S. Army (1942–46). Moves to New York (1946–50). Works as a commercial artist and attends lectures at Robert Motherwell's Studio 35 and drawing sessions at Art Students League (1946–50). Returns to Berkeley (1950) and attends University of California, Berkeley (BA 1952, MA 1953, MLS 1955). Meets future life partner Theophilus Brown (1952). Participates in figure drawing sessions with Elmer Bischoff, David Park, Richard Diebenkorn, James Weeks, and others (1955–57). Starts painting a series of male bathers and boys with bouquets; also begins incorporating influences of French intimist painters Pierre Bonnard and Edouard Vuillard and working with gouache, a medium in which he excels (1956). First solo exhibition at M. H. de Young Memorial Museum, San Francisco (1956). Moves to Davis to work in University of California, Davis, library (1956). Included in seminal "Contemporary Bay Area Figurative Painting" exhibition curated by Paul Mills at Oakland Museum (1957). Returns to San Francisco (1960). Guest instructor in painting at University of California, Los Angeles (1960). First New York solo exhibition at Poindexter Gallery (1962). Moves to Malibu, CA (1961–62). Moves to Santa Barbara to teach at University of California, Santa Barbara (1968); remains in Southern California (1974). Abandons loose figurative style and begins focusing exclusively on still-life compositions, done in the tradition of seventeenth-century Dutch super-realist painting (late 1960s). Returns to Berkeley (1974), then San Francisco (1976). Begins relationship with John Berggruen Gallery, San Francisco (1978). San Francisco Museum of Modern Art organizes traveling exhibition "Paul Wonner: Abstract Realist" (1981). Currently lives and works in San Francisco.

SELECTED READING

GENERAL BOOKS AND ARTICLES

Albright, Thomas. *Art in the San Francisco Bay Area 1945–1980: An Illustrated History*. Berkeley and Los Angeles: University of California Press, 1985.

Dawtrey, Liz, Toby Jackson, Mary Masterton, and Pam Meecham, eds. *Investigating Modern Art*. New Haven: Yale University Press, 1996.

Ehrlich, Susan, ed. *Pacific Dreams: Currents of Surrealism and Fantasy in California Art 1934–57*. Berkeley and Los Angeles: University of California Press, 1995.

Gaiger, Jason. *Frameworks for Modern Art*. Vol. 1 of *Art of the Twentieth Century*. New Haven: Yale University Press; Milton Keynes, UK: The Open University, 2003.

Greenberg, Clement. *Art and Culture*. Boston: Beacon Press, 1961.

Jones, Caroline A. *Machine in the Studio: Constructing the Postwar American Artist*. Chicago: University of Chicago Press, 1996.

———. *Bay Area Figurative Art: 1950–1965*. Berkeley and Los Angeles: University of California Press; San Francisco: San Francisco Museum of Modern Art, 1990

Karlstrom, Paul J. ed. *On The Edge of America: California Modernist Art 1900–1950*. Berkeley and Los Angeles: University of California Press, 1996.

Landauer, Susan. *The San Francisco School of Abstract Expressionism*. Berkeley and Los Angeles: University of California Press, 1996.

McChesney, Mary Fuller. *A Period of Exploration: San Francisco 1945–1950*. Oakland: The Oakland Museum, 1973.

Mills, Paul. *Contemporary Bay Area Figurative Painting*. Oakland: Oakland Art Museum, 1957.

Perl, Jed. *New Art City: Manhattan at Mid-Century*. New York: Alfred A. Knopf, 2005.

Rosenberg, Harold. "The American Action Painters," *ARTnews* (December 1952): 25.

Sandler, Irving. *The New York School: The Painters and Sculptors of the Fifties*. New York: Harper & Row, 1978.

Selz, Peter and Kristine Stiles, eds. *Theories and Documents of Contemporary Art: A Sourcebook of Artists' Writings*. Berkeley and Los Angeles: University of California Press, 1996.

Wood, Paul, ed. *Varieties of Modernism*. Vol. 3 of *Art of the Twentieth Century*. New Haven: Yale University Press; Milton Keynes, UK: The Open University, 2004.

MONOGRAPHS AND BIOGRAPHIES

Amerson, Price, John Beardsley, Jack Cowart, Henry Geldzahler, and Robert Pincus. *Manuel Neri 1953–1978*. Washington, D.C.: The Corcoran Gallery of Art, 1996.

Anfam, David. *Clyfford Still*. New Haven: Yale University Press; Washington, D.C.: Hirshhorn Museum and Sculpture Garden, 2001.

Burgard, Timothy Anglin, Walter Hopps, Bruce Nixon, Robert Flynn Johnson, Bruce Guenther, and Anthony Torres. *Frank Lobdell: The Art of Making and Meaning*. San Francisco: Fine Arts Museums of San Francisco, 2003.

Elderfield, John. *Frankenthaler*. New York: Harry N. Abrams, 1989.

Hunter, Sam. *Hans Hofmann*, Rev. ed. New York: Rizzoli, 2006.

Kertess, Klaus. *Joan Mitchell*. New York: Harry N. Abrams, 1997.

Landauer, Susan. *Elmer Bischoff: The Ethics of Paint*. Berkeley and Los Angeles: University of California Press; Oakland: Oakland Museum of California, 2001.

Livingston, Jane. *The Art of Richard Diebenkorn*. New York: Whitney Museum of Art, 1997.

Mills, Paul. *The New Figurative Art of David Park*. Santa Barbara, CA: Capra Press, 1988.

Nordland, Gerald. *Richard Diebenkorn*, Rev. ed. New York: Rizzoli, 2001.

Ratcliff, Carter. *The Fate of a Gesture: Jackson Pollock and Postwar American Art*. New York: Farrar, Straus & Giroux, 1996.

Stevens, Mark and Annalyn Swan. *De Kooning: An American Master*. New York: Alfred A. Knopf, 2004.

Tsujimoto, Karen and Jacquelynn Baas. *The Art of Joan Brown*. Berkeley and Los Angeles: University of California Press, 1998.

Weiss, Jeffrey and Barbara Novak, et. al. *Mark Rothko*. New Haven: Yale University Press, 2000.

ARTIST INDEX